LEONARDO DA VINCI
NATURE STUDIES

Leonardo da Vinci Nature Studies from the Royal Library at Windsor Castle

The Museum of Fine Arts, Houston

7 February - 4 April 1982

Catalogue by CARLO PEDRETTI

Introduction by KENNETH CLARK

JOHNSON REPRINT CORPORATION

CONTENTS

*The drawings are reproduced by gracious permission
of Her Majesty Queen Elizabeth II*

*This exhibition has been made possible
through the generous support of Getty
Oil Company, Southern Exploration and
Production Division*

DESIGNED BY THE AUTHOR
LIBRARY OF CONGRESS CATALOG NUMBER 81-84558
© 1980 JOHNSON REPRINT CORPORATION
PREFACE COPYRIGHT © 1981
ISBN NUMBER 0-384-32298-0
PRINTED IN ITALY

FOREWORD
BY
ROBIN MACKWORTH-YOUNG
LIBRARIAN, WINDSOR CASTLE

Of all the men of genius who played a part in the Italian Renaissance, none is more remarkable than Leonardo da Vinci. Master of any discipline to which he set his hand—painting, sculpture, architecture, anatomical dissection, engineering, music—he exemplified the spirit of enquiry about nature to which the vast corpus of modern scientific knowledge owes its origin.

The impact of his genius has been preserved for us more directly than that of most of his contemporaries by his extraordinary talent for drawing. This he used for recording his thoughts, experiences and discoveries much as a diarist or a scholar uses words, thus preserving for a later age intimate access to the very workings of his mind. An idea is set down as it emerges, perhaps filling a vacant space on an already crowded sheet. A few strokes of chalk, pen or stylus suffice not only to record some outer object—or some product of the imagination—but also to invest it with an inner energy, often of striking intensity. Sometimes he is processing a detail for a larger composition, sometimes simply recording knowledge. Words are not excluded, but are usually supplementary, appearing as comment by the side of some sketch. One such comment on an anatomical drawing explains his method. The use of drawing gives "knowledge which is impossible for ancient or modern writers [to convey] without an infinitely tedious example and confused prolixity of writing and time."

On Leonardo's death the contents of his studio, which included several thousand drawings, passed to his favourite pupil Francesco Melzi, whose handwriting may be seen on 24 in the present exhibition, and who was probably responsible for 23, a view of Amboise seen from the window of Leonardo's bedroom at Clos-Lucé. On his death (c. 1570) most of the collection was bought by the sculptor Pompeo Leoni, who rearranged the folios and bound them into volumes. Leoni, who was court sculptor to the King of Spain, took some of the volumes to Madrid. After his death in 1609 one volume, containing examples of every field in which Leonardo worked, was acquired by the celebrated English collector, Thomas Howard Earl of Arundel, who brought it to England. While it belonged to him some of its drawings were engraved by Hollar. Arundel had to leave the country during the Civil War, and it is uncertain whether or not he took the volume with him. According to Count Galeazzo Arconati, who gave other Leonardo manuscripts to the Ambrosian Library in Milan, drawings concerning anatomy, nature and colour were "in the hands of the King of England" before 1640. This statement, and the fact that virtually all the surviving anatomical drawings by Leonardo are now in the Royal Collection, having formed part of the volume bought by Arundel, suggests that the volume did not leave the country, but was acquired by King Charles I. Others have surmised that it may not have reached the Royal Collection until after the restoration of King Charles II, to whom it could well have been sold or presented by Sir Peter Lely, one of the keenest collectors of drawings of his day. By whatever route it reached the Royal Collection, it is recorded as being in the possession of Queen Mary II in 1690, one year after she and her husband ascended the English throne as joint monarchs.

[5]

This volume contained all the six hundred folios now at Windsor. During the three centuries that they remained within its covers those executed in chalk suffered considerably from rubbing. To prevent further damage most of the single-sided drawings were laid down on separate mounts in the nineteenth and early twentieth centuries. The mounting-board used for the purpose has proved to possess a high acid content, and to avoid discoloration and ultimate disintegration of the paper the folios are now being lifted from their mounts and encased within a protective covering of acrylic sheeting. This process, originally designed for folios bearing drawings on both sides, has already been applied to the anatomical folios—which are almost all two-sided—and has now been extended to those in the present exhibition.

The full range of Leonardo's genius is best grasped by giving separate consideration in turn to each field in which he worked. A selection of his anatomical drawings was exhibited in Washington and Los Angeles as part of the bicentennial celebrations in 1976. This selection was expanded in an exhibition which was shown in London in 1977, and later in Florence and Hamburg.

The present exhibition is concerned with landscapes, botanical drawings, and studies of the flow of water. All the drawings selected for this exhibition will be included in a new publication containing facsimiles of all the drawings by Leonardo on these subjects at Windsor. This edition will incorporate a new catalogue raisonné compiled by Professor Carlo Pedretti, the foremost contemporary authority on the works of Leonardo, with an introduction by the doyen of Leonardo scholars, Lord Clark. The entries in, and introduction to, the present catalogue are by the same authors and are based on their contributions to that work.

PREFACE

The genius of Leonardo da Vinci is as compelling today as it was for his contemporaries. His pioneering explorations as an artist, architect, engineer, and scientist still yield an astonishing vision of the world that is virtually inexhaustible. This exhibition of fifty drawings, selected from the nearly 600 Leonardo drawings belonging to the Queen of England and housed in the Royal Library at Windsor Castle, is devoted to one aspect of his genius, the nature studies. They range from his observations of simple plants to the raging deluge series, and all demonstrate Leonardo's unsurpassed skill and sensitivity as a draughtsman.

The Board of Trustees and the staff of The Museum of Fine Arts, Houston are deeply grateful to Her Majesty Queen Elizabeth II for kindly granting permission for these drawings to travel to Houston. I would like to express the Museum's particular appreciation to Sir Robin Mackworth-Young, Royal Librarian at Windsor Castle, for his generous assistance in bringing the exhibition to the Museum. We are grateful to Jane Roberts, Curator of the Print Room at Windsor Castle, and to her staff, for their indispensable work in coordinating the difficult logistics. Paul Williams designed and oversaw the installation with enormous skill and sensitivity, and we owe him special thanks. I am grateful to Carlo Pedretti who wrote the catalogue and whose superb scholarship informs every aspect of the exhibition.

We are deeply grateful to Getty Oil Company, Southern Exploration and Production Division, for providing the funding that has made this exhibition possible. We wish especially to thank Judd H. Oualline, Vice President and Division General Manager, and Michelle Beale, Manager of Public Affairs, for their generous assistance with this grant.

I would like to thank the staffs of the Metropolitan Museum of Art and the J. Paul Getty Museum, where the exhibition was first shown, for kindly providing advice and assistance. I also am grateful to the many people on the staff of The Museum of Fine Arts, Houston who carried out crucial roles in the course of preparing the exhibition. Special thanks are due to Barbara Rose, Curator of Exhibitions and Collections; Celeste Adams, Chairman, Department of Education; Judith McCandless, Associate Curator; Karen Bremer, Assistant Curator; Maggie Olvey, Curatorial Assistant; Ginna Grimes, Administrative Assistant; Edward Mayo, Registrar, and his staff; Ron Jarvis, for coordinating the Houston edition of the catalogue; Erik Binas, Preparator, and his staff; and Jack Eby, Designer.

WILLIAM C. AGEE
Director
The Museum of Fine Arts, Houston

[7]

INTRODUCTION

IN FIFTEENTH century Florence many painters had concerned themselves with landscapes, flowers and trees. Plants and flowers had been one of the favourite subjects of the late gothic artists who held the field in the first half of the century, and one of them, Gentile da Fabriano, had used flowers to fill the spaces in the frame of his most famous altarpiece. Fra Angelico, at about the same date, not only included carefully observed flowers in the foregrounds of his pictures, but related them to the distant landscape. And Baldovinetti felt so deeply the fascination of nature that his *Nativity* in the Servi could almost be described as a landscape with figures. All these pictorial details presuppose a great many drawings of flowers, but practically none of them have survived. They were not valued except as means to an end.

Leonardo's drawings of flowers and landscapes must therefore be seen in the context of an exercise that had been going on for over fifty years. 'Molti fiori ritratti di naturale' are mentioned in an early list of Leonardo's works in the Codex Atlanticus (Richter, § 680). These flower studies have not survived either, the well known sheet at Venice, usually thought to be one of them, being a much later drawing by Francesco Melzi. For the 1483 commission of the *Virgin of the Rocks* in Milan Leonardo went back to extensive plant studies. Flowers again 'ritratti di naturale' appear in Paris MS. B, but he soon came to be exposed to the local practice of studying medieval herbals, that curious mixture of Christian symbolism, decorative patterns and scientific observations which, like the more popular *Bestiari*, must have been very appealing to him and which he must have sought very eagerly to acquire. 'Maestro Giuliano da Marliano à un bello erbolaro' he writes about 1493 (Richter, § 1386). And so by 1504 he owned one such herbal, which is in fact mentioned in his book-list in the second of his Madrid manuscripts: 'erbolajo grande'. There is also some evidence that he had planned to compile his own collection of plant drawings, and although the plant studies dating from after 1504 can be related with reasonable certainty to the subject of *Leda*, some of them unquestionably approach the character of botanical specimens. One in particular, 19, with its accompanying notes, would fit precisely the category of scientific illustrations of the kind that was to appear later in the sixteenth century in Ligozzi's illustrations for the *Natural History* of Ulisse Aldrovandi.

As Leonardo's treatment of the subject had become more scientific than anything that had preceded him, it is only natural that he should have come to consider plants in relation to the terrain in which they grow, hence the extraordinary sense of vitality in his drawings of rock formations, so often shown in conjunction with plants and water. And water was soon to be shown in its dashing, destructive fury as part of an overall vision of atmospheric activities and turbulence. It all probably started in the backgrounds of Uccello's *Deluge* and Pollaiuolo's *Rape of Dejanira*, but Leonardo's late drawings of storms and cataclysms have no precedent in their scientific accuracy and in the sense of incumbency which they convey by a dramatic use of light and shade. And so we rightly see him as a precursor of Turner.

A new consciousness of the optical phenomena in aerial perspective, as first manifested with Masaccio and as codified by Alberti, had a curious effect on masters of line and colour such as Domenico Veneziano, Gozzoli, Uccello and even Piero della Francesca. Departing from their northern colleagues, they developed a sort of impressionistic convention in rendering the form of mountains and the appearance of fields and trees in the far distance. This explains Botticelli's attitude towards landscape as criticised by Leonardo himself in a famous chapter of his Treatise on Painting: 'If one does not like landscape, he esteems it a matter of brief and simple investigation, as when our Botticelli said, that such study was

[9]

vain, because by merely throwing a sponge full of diverse colours at a wall, it left a stain on that wall, where a fine landscape was seen... And such painter made very poor landscapes' — 'E questo tal pittore fece tristissimi paesi' (Lu 60, McM 93).

The earliest landscape drawing by Leonardo is a well known sheet in the Uffizi inscribed 'dj dj sta Maria della neve, addj 5 daghossto 1473'. This is in fact his earliest dated drawing, and the inscription suggests that Leonardo did a sequence of studies of the landscape of the Val d'Arno, of which only one sheet has survived. It is completely naturalistic, and is drawn in a bold, free style usually referred to as impressionistic. Only one of the drawings at Windsor has any resemblance to it, a study of the rocky bank of a stream, on the surface of which are swimming two badly drawn ducks (3). In the first edition of my catalogue of the Leonardo drawings in the Royal Collection I found this resemblance to the Arno landscape close enough to suggest a very early date for this drawing, but the rocks are drawn with a scientific knowledge of their geological character which would have been improbable in the 1470s, and in the second edition of the catalogue I changed the suggested date to *c*. 1481. I also surmised that they could be related to the studies used for the setting of the *Virgin of the Rocks*. This would give a date 1481-3; and to this suggestion I still adhere. The magnificent drawing of stratified rocks, 37, may at first sight seem to belong to about the same period but the geological structure is understood with greater knowledge and, if studied attentively, the style seems to be consistent with that of the anatomical drawings of about 1510.

The next drawing to be considered, 4, is the splendid view of a storm breaking over the foothills of the Alps, with a town in the middle distance and the high Alps visible in the background. It is, perhaps, the most famous of Leonardo's landscape drawings and from every point of view the most important. But it is very hard to date. It has often been associated with the background of the *Mona Lisa*, but is more naturalistic, and more closely related to the landscape studies on 5 and 6. Recent critics have seen it as connected with the landscape of the Louvre *Virgin and St Anne*. But as neither of these paintings can be dated with any certainty we are no further forward, and it is perhaps safer to assume that they retain a memory of Leonardo's visit to the Alpine regions in the Veneto in the first months of 1500. In the same group of red chalk drawings we should, I think, place the study of a copse, 7A. Technically it is a miracle. How did Leonardo sharpen a piece of red chalk so that he could delineate the boughs and leaves of the tree on the right? People who know the drawing only from ordinary reproductions have assumed that it is far larger.

An unusually firm basis for dating a series of Leonardo's landscape drawings is provided by the notes on 24, which explain how the two drawings on it represent the fires lit by the Swiss troops in their retreat from Milan on the way to Desio in December 1511. Leonardo's brief account of the historical event and the pertinent drawings are in red chalk on red prepared paper; because they had begun to fade his pupil Francesco Melzi transcribed the notes using pen and ink. The characteristic technique, which Leonardo had already employed in his anatomical studies (and in fact the sketches of a leg and of a foot appear on 24) could well serve to enhance the atmospheric effect of distant mountain ranges as in the best known drawings of this series (26, 28). They show that Leonardo's skill as a delineator of landscape had positively increased: in particular he had become more interested in effects of atmosphere, even though the accompanying notes explain how vegetation is affected by the nature of the ground.

The optical truth of 26 has never been surpassed in a drawing. A similar insistence on truth is apparent in a series of minute and delicate pen drawings of river banks, 33-36, datable *c*. 1513. They are views focussed on spots around the Villa Melzi at Vaprio d'Adda, the residence of Leonardo's pupil Francesco Melzi. What can have induced him to execute these miniatures, except his restless desire to excel in everything? One may fancy about a possible response to a strong Lombard tradition of book illuminators, and we are told that

Melzi himself was to continue that tradition. But these Adda River landscapes have the precision of the intricate ramifications of blood vessels and capillary veins in Leonardo's anatomical drawings of about the same time, and this makes one wonder whether the analogy between man and the vegetable growth so repeatedly stressed in his writings had finally reached a visual dimension.

We come now to those black chalk drawings of rock formations which, by a chain of evidence, can be convincingly related to the background of the Louvre *Virgin and St Anne* (e.g. 8) and are therefore datable well after 1506. They are bold, powerful drawings, at the opposite pole to the delicate, detailed 33, although they may be of almost the same date. They lead directly to 12, the precursor of the ten drawings usually referred to as the Deluge Series (40-49).

These Deluge drawings are in many ways the strangest of all Leonardo's many strange legacies to posterity, and to see them in perspective we must begin by looking at Leonardo's numerous drawings of swirling water. Those included in this exhibition, 29-32, represent the summation of a long series of water studies begun in the early 1490s and carried on with greater intensity from after 1508, at a time when Leonardo came to equate the movement of water to that of blood or to that of wavy hair, as the note on 32 explains. It is possible to give material or mechanical explanations of these drawings. All his life Leonardo's mind was occupied by problems of water power and, given his habit of studying scientific questions by delineating actual examples, we might maintain that the streams of water on 31 are the record of disinterested observation undertaken in order to establish certain laws of hydro-dynamics. The notes to be found on many of the drawings support this point of view. But personally I think it gives a misleading idea of Leonardo's character. In contrast to the notes, the drawings are far from being disinterested observations. Even Leonardo's exceptionally acute powers of sight never saw the curls of water as they are depicted in the centre of 31. They are abstractions expressive of his feelings about the movement of water. These feelings or, to speak more accurately, this obsession, which had for long been satisfied by relatively naturalistic studies (32) gradually came to demand a symbolic form. We can see the birth of this whirlpool symbolism on the beautiful and famous drawing 29A. On the upper part are the studies of swirling water done direct from observation; below there is a creation of Leonardo's visual imagination, a wonderful flower or cluster of flowers, surrounded by tendrils, yet still containing some of the energy of the water. The note is entirely factual, and persuades one to look back at the drawing as a scientific record: but without success. Whatever its original intention, it has become a symbol.

This conclusion leads me to ask whether the drawings known as the Deluge Series were not connected in Leonardo's mind with some visions of the end of the world. This speculation is supported by the drawings on 48, which are openly apocalyptic. The indecipherable happenings on 49 hint darkly at this same conclusion. All of which strongly suggests that, although the only notes on Deluge drawings, 42 and 48, are simply records of observations, the intention of these drawings, 48 above all, is not strictly scientific. It is true that Leonardo may have witnessed some very severe storms, both in Tuscany (in particular on 3rd July 1514), and in the Italian Alps. But he never supposed that a storm, however severe, would cause hills to fall like piles of bricks, or that water would spout up from the ground in gigantic curves. He depicts these impossible phenomena because he is using them as symbols of universal destruction. These Deluge drawings are not scientific but symbolic. In some instances, e.g. on 43, they produce an effect which is genuinely alarming; in others, e.g. on 42, the flower is more decorative than terrifying. And finally, the same turbulence of wind storms and clouds and gushing waters appears in the fluttering drapery of the 'Pointing Lady', 39, herself an enigmatic symbol of the working of Nature, majestic and alluring as an ancient goddess, haunting and ethereal as a gothic Virgin.

11

This interplay between science and symbolism is one of the most fascinating aspects of the action of Leonardo's mind on his later years, and helps to account for the fact that his contemporaries came to think of him less as an artist and more as an old magician whose mind was stocked with terrible secrets about the universe. It also helps to explain why these drawings never became paintings. 'One of the first painters of the world', wrote Baldassare Castiglione in his *Cortegiano*, 'scorns that art wherein he is most rare, and has set about studying philosophy; in which he comes up with such strange notions and new chimeras that, for all his art as a painter, he would never be able to paint them'.

KENNETH CLARK

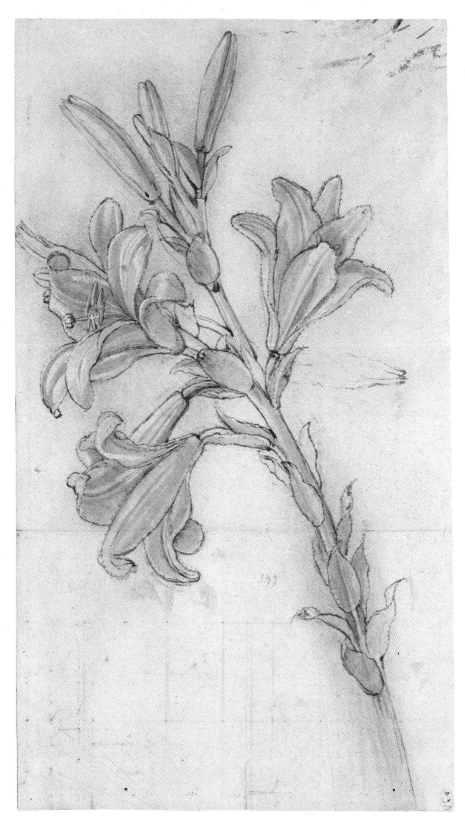

I Stalk of a lily with a head of flowers [2]

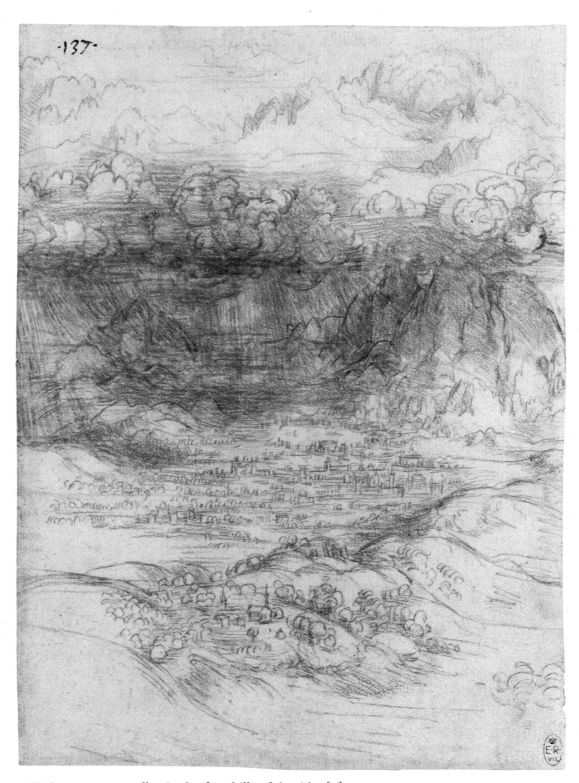

II Storm over a valley in the foot-hills of the Alps [4]

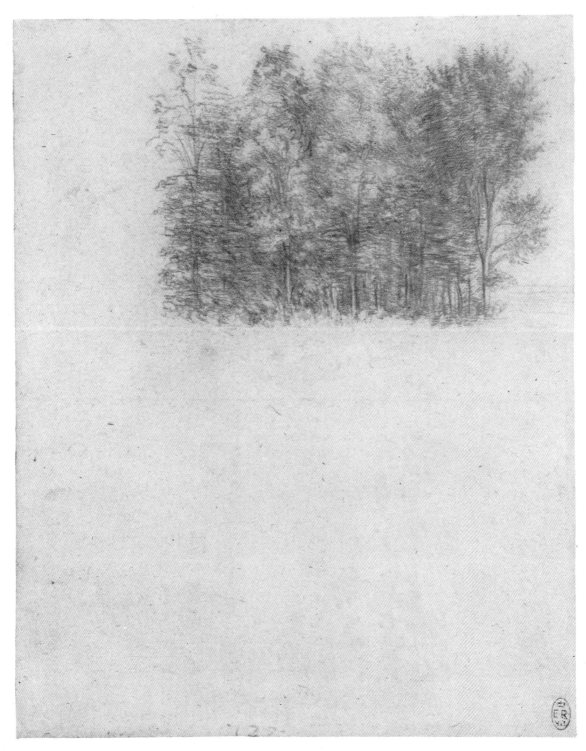

III Copse of birches [7A]

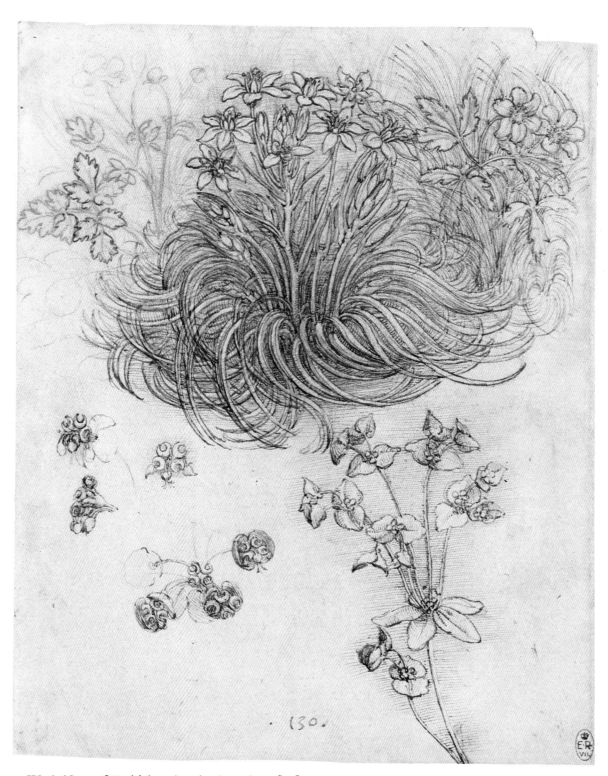

IV A 'Star of Bethlehem' and other plants [13]

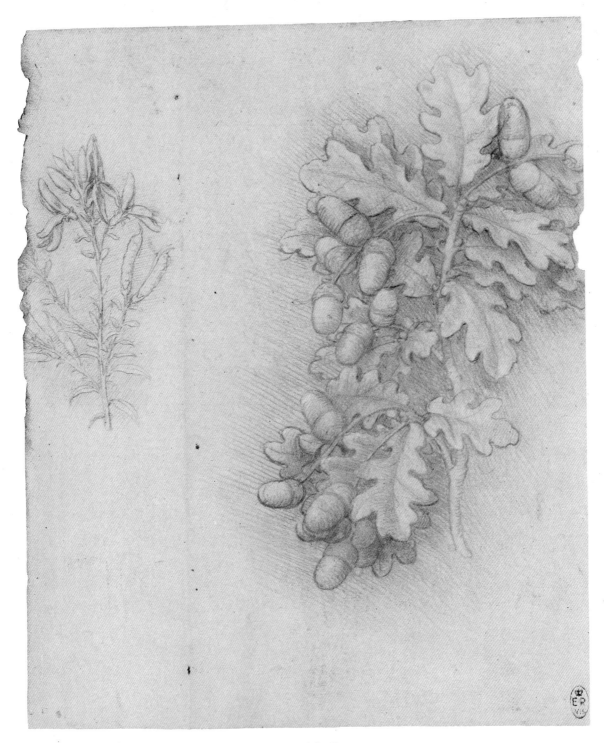

V Sprays of oak leaves and Dyer's greenweed [15]

153

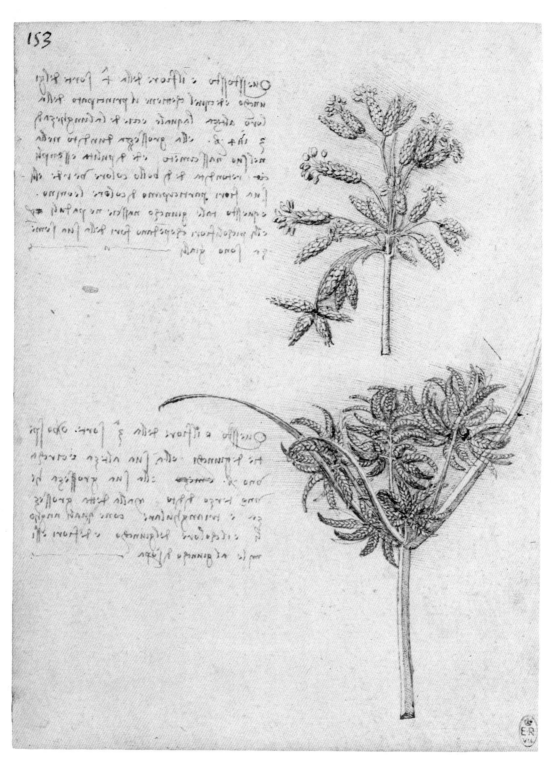

VI Heads of two different types of rush [19]

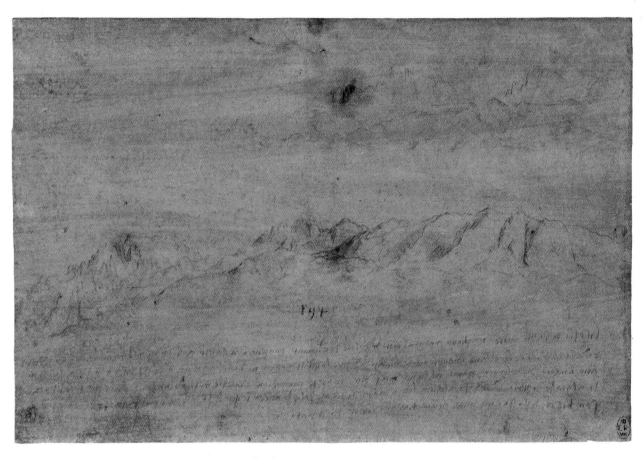

VII Two mountain ranges, with notes [26]

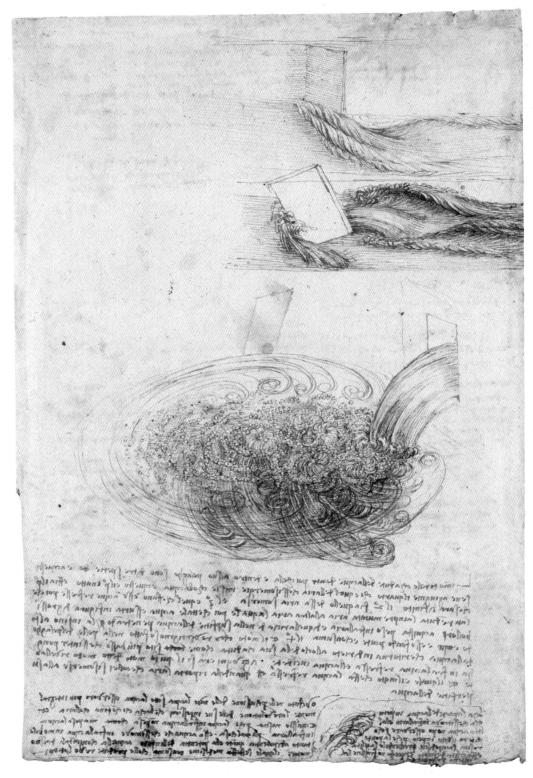

VIII Sheet of studies of water passing obstacles and falling into a pool, with notes [29A]

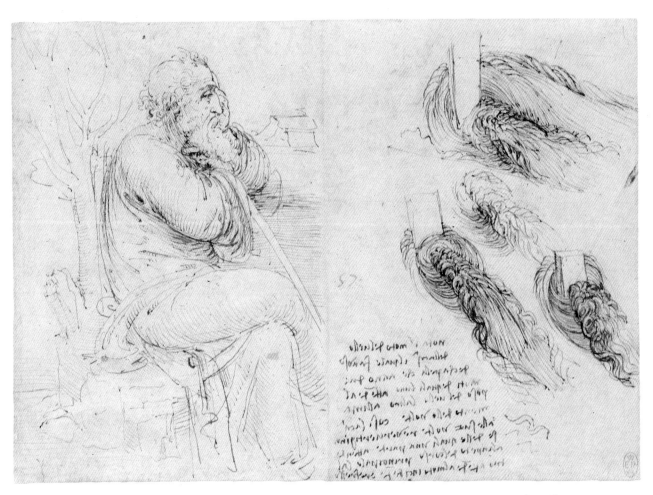

IX An old man in profile to right, seated on a rocky ledge; water studies and a note [32A]

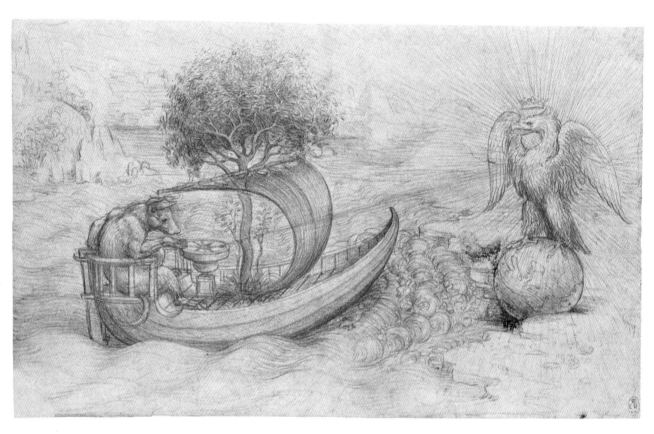

X Allegory of river navigation [38]

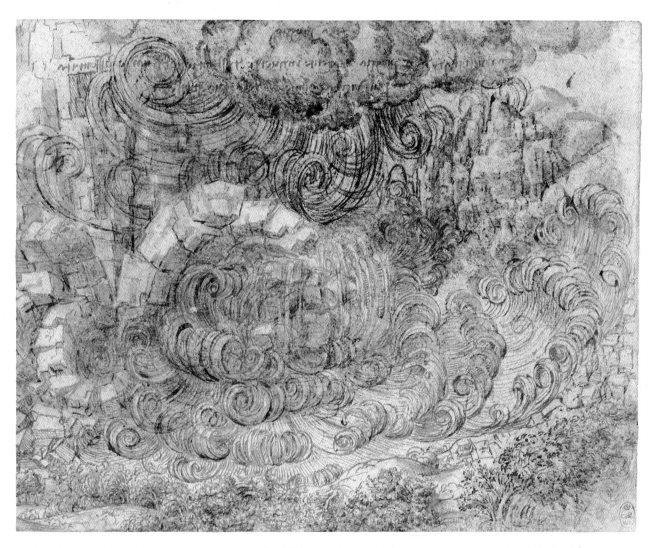

XI Mountain range burst open by water, the falling rocks producing enormous waves in a lake [42]

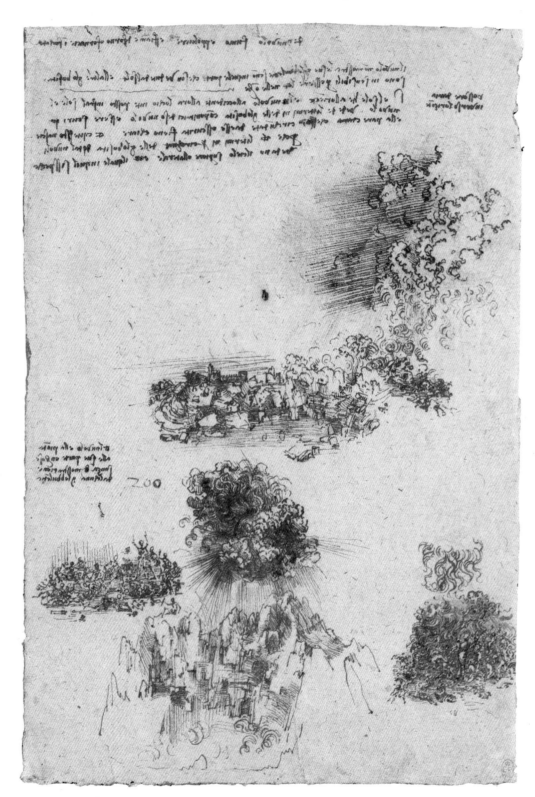

XII Sheet of miscellaneous studies of destruction falling on the Earth with notes[48]

CATALOGUE

NOTE

The fifty drawings in this exhibition are arranged in an approximately chronological sequence. They represent an almost complete corpus of Leonardo's nature studies at Windsor, as included in the forthcoming facsimile edition. Their subdivision into ten categories is also as adopted in that edition. The format of the present catalogue is basically the same as that of the anatomical studies exhibited at the Royal Academy, London in 1977–8, and at the Palazzo Vecchio, Florence, and the Kunsthalle, Hamburg, in 1979. As such, it does not include bibliographies to the individual entries, but a Bibliographical Note follows the Tables of Concordance at the end.

Measurements are given in millimetres, height preceding width. The drawings are on white paper unless otherwise indicated. For a List of Abbreviations see p. 94.

THIS SHEET, one of the largest in all collections of Leonardo's papers, is an extraordinary document of Leonardo's mind at work. It encompasses the full range of his scientific curiosity and exhilarating artistic whim, as it displays his analytical powers and the thoughtful wandering of his fantasy. In the new edition of his drawings and miscellaneous papers at Windsor it is appropriately placed at the beginning as a 'theme sheet', in that it contains elements of all four planned classifications of those drawings: (1) landscapes, plants and water studies, (2) horses and other animals, (3) figure studies, and (4) miscellaneous papers including scientific notes. It is also one of Leonardo's earliest sheets. Style and content point to the time of his first anatomical studies, c. 1489-90, and to nature studies as well as geometry and technology in Paris MSS. A and B, which date from about the same time.

As it pertains to the first decade of Leonardo's activity in Lombardy, it may be taken to reflect the style of his nature studies related to his first painting in Milan, the *Virgin of the Rocks* commissioned in 1483 (see 3 below). It is both controlled and carefree, showing incomparable skill in handling the pen to produce a firm, probing line with the precision of an engraving and with a vibrating translucency evocative of the colouristic touch of the chalk. All visual impulses determined by figure and plant studies within the abstract framework of geometrical diagrams, lead to the image of the ever-changing forms of clouds in the small drawing at the far right. An almost symbolic link between art and science is provided by the character of the slanting lines of shading, which is the same in the geometrical diagrams and in the study of cloud formation. Indeed, a symbol may be perceived in this juxtaposition, as the endless manipulation of geometrical forms was to become one of Leonardo's major preoccupations in later years, with a bearing on his concept of life as energy, and therefore as a process of everlasting transmutation. It is here, on this sheet, that one detects the first symptoms of his visionary concept of the 'end' of the world in terms of the unbridled forces of nature as presented in the series of Deluge drawings with which his landscape studies are brought to a conclusion (see 40-50 below).

1A *Sheet of miscellaneous studies and notes, including the bust of an old man, cloud, water, plant and geometry studies*

Pen and ink and stylus, 320 × 446 mm. (P 1 r; RL 12283 r).

It is tempting to view the geometrical diagrams as an integral part of the overall composition. One can sense that Leonardo had deliberately related them to the figurative elements as a means of establishing balance and rhythm on the page. Thus the diagram at the back of the old man's profile comes to be curiously incorporated in the outline of his drapery and on the left it springs out to carry the same impulse of the pen into the shaping up of rock formations. This could be described as a form of doodle, but it is hard to believe that Leonardo's hand was just guided by some fancy mood. The bare tree behind the one in leaf is brought up over the chest of the man, and its ramifications, like the unseen veins of the man's lungs, are spread out to merge into the folds of his mantle. This gigantic human presence rising from behind the promontory on which the two trees are placed could almost be sensed as a prefiguration of Goya's *El Coloso*.

The horse and figure studies may reflect Leonardo's ideas for the equestrian monument of Francesco Sforza, but are more probably related to his illustrations of war tactics as shown in Paris MS. B.

Although it is indeed true that anatomy is excluded from this sheet, the style and character of the drawings unmistakably relate it to the early anatomical studies. Here is in fact the style and character of the drawings of the skull in the 1489 section of Anatomical MS. B

[27]

at Windsor, and this, almost paradoxically, can be perceived more clearly in the drawing of clouds than in the classical looking profile of the old man. And in keeping with the scope of Leonardo's early programmes of physiological investigations, the pervading sense of the organic, as best revealed by the plant study at top left, prefigures the character of the curling grass in the drawings for the vegetation in the setting of *Leda* (compare 13 below).

1B *Geometrical studies*

Pen and ink and stylus (P 1 v; RL 12283 v).

Like the studies on the recto, these might have been inspired by Alberti's short treatise *De lunularum quadratura*. In fact, a 'lunula' is mentioned in the note within the superimposed circles. The hexagonal figure at bottom right suggests the optical illusion of interpenetrating volumes.

Evidence of Leonardo's extensive study of plants and flowers in his youth is provided by Leonardo himself as he records 'molti fiori ritratti di naturale' in the list of works that about 1482 he was taking to Milan or leaving in Florence. And nearly every one of his early paintings, either surviving or recorded in contemporary descriptions, contained prominent elements of landscape, in particular vegetation. Plants and flowers are consistently represented with scientific accuracy in such works as the two *Annunciations*, the portrait of *Ginevra Benci*, the *Adoration of the Magi* and the *Madonna of the Carnation* at Munich, possibly the painting recorded by Vasari as belonging to Clement VII and as including a 'caraffa piena d'acqua con alcuni fiori dentro'. And it was presumably from the same time that the cartoon for a door hanging representing *Adam and Eve in the Garden of Eden* was made for the King of Portugal, but now lost. Vasari speaks of it as containing a wealth of botanical specimens, including 'a meadow of endless kinds of herbage'.

As a document of the collaboration between Leonardo and his teacher Verrocchio, a drawing for a ceremonial banner representing *Venus and Cupid* at the Uffizi reflects the type of plant study that Leonardo must have produced in the mid-1470s. The line runs fast and bold to define contour, and varies in intensity and thickness to aptly convey the flexibility of stems and leaves. This quality of line comes to be enhanced by a watery ink that can turn hatching into blots as in another early drawing at the Uffizi, the famous landscape of the Arno valley dated 5th August 1473, when Leonardo was 21. The effect is one of exhilarating speed in catching a fleeting image in the expanse of an open field — the dashing waters of a river or the rotating effect in the branches of shrubs and trees viewed through the haze of a summer day in Tuscany. And when the image is brought to a close-up, as with the drawing of a lily in 2, the speed is brought down to a rippling movement.

The drawings dating from the first years in Milan, from about 1482 to 1485, retain much of this exuberant, at times impetuous quality of line, as shown by a number of studies for the *Madonna of the Cat*, which can now be recognised as belonging to Leonardo's early Milanese period. But with this also comes a line already tested in technological drawings — sharp, neat, and controlled. Applied to a landscape or to elements of landscape, it is suitable to convey information rather than impressions. And so with the drawing of the rocky bank of a stream of water, 3, a probing quality of line is being tested for its effectiveness to deal with structure, and one can sense that the same line will soon penetrate the human body.

2 *Stalk of a lily with a head of flowers* (Plate I)

Pen and ink and wash over black chalk, pricked for transfer, 314 × 177 mm. (P 2 r; RL 12418).

The subject immediately suggests the lily of the angel in an Annunciation scene, and since the drawing is pricked for transfer it should correspond exactly with the lily in the Uffizi *Annunciation*. This is not the case. Not only does it differ in the arrangement of flowers, buds and leaves, but it leans the opposite way as if intended to be held over the angel's shoulder as in the *Annunciation* by Lorenzo di Credi at the Uffizi. One of the angels in the Verrocchiesque *Madonna* in the National Gallery, London, is holding a lily which is very close but not identical to that in this drawing. The style of the drawing points to the mid-1470s, the same time as the London painting and presumably the time when Leonardo started the Uffizi *Annunciation*. The touch of the pen is the same as in the study for the angel's sleeve at Oxford, but

it is confined to a slower contour line as in the *Adoration* horses at Cambridge. Clark speaks of its style as 'quite unlike that of Leonardo's other botanical studies'. In its almost unique combination of pen and ink and wash it is comparable to a drawing of a Dragon Fight purchased by the British Museum in 1952. The thick, almost rough contour line appears in a fragment at the Uffizi (no. 449 E), with a Verrocchio type of profile on the recto and the profile of a youth on the verso. This has been convincingly related to the profile of the angel in the Uffizi *Annunciation*, and in fact it even includes an indication, however slight, of the stalk of a lily held in front of the angel's face.

3 *Stream running through a rocky ravine, with birds in the foreground*

Pen and ink, 220 × 158 mm. (P 3 r; RL 12395).

This is not necessarily a study for the first version of the *Virgin of the Rocks*, commissioned in 1483, but it shows the same character of rock formation in relation to water and vegetation as in the background of that painting. The emphasis on horizontal lines of shading to convey the effect of translucency and transparency in the water, appears already in the 1473 Arno landscape at the Uffizi, where the aim is still somewhat 'impressionistic', and natural forms are not as carefully defined as in the present drawing. As in similar landscape drawings of forty years later, the Adda river series (compare 33–37 below), one can speak of 'optical truth' (Clark). But a keen sense of geological structure, as already present in this early drawing, is never devoid of emotion, and this may be unexpectedly enhanced by a humorous touch such as that of a duck flapping its wings. The record of a scientific observation is thus turned into an idyllic sight, of a kind that would have appealed to Petrarch.

NARRATIVE LANDSCAPES

A BOUT 1487 Leonardo was taken by the fancy of writing a fiction. The story was about the apparition of a fierce giant, said to have been born on Mount Atlas and to have terrorized the near Eastern regions since Artaxerxes's time. The narrative is in the form of letters addressed to his friend Benedetto Dei, one of the most extravagant characters of the whole fifteenth century, a traveller and an adventurer, one who would himself come up with extraordinary tales and make a living by visiting the various European courts to sell exotic stories and merchandise as well as the incomparable riches of his native tongue.

Leonardo's story of the giant hints at a prefiguration of the fabulous world of Gulliver's *Travels*, and yet it is not an isolated occurrence. This becomes clear when viewed in a cultural context so familiar to Leonardo, that of the chivalric tradition which includes the French romances of the knights of the Round Table and which is best represented in Italy by the very popular adventures of Guerin Meschino, a book in fact owned by Leonardo, in which the narrative unfolds against an ever-changing scenery of fabulous lands and sea views. From another popular story, *La bella reina d'Oriente* by Antonio Pucci, Leonardo transcribed an octave about another giant, described as being 'più nero che un calabrone'. And of course he must have been familiar with Pulci's *Il Morgante*, of which he owned a copy, and which is one of the very few books known to have been read by Raphael as well.

And the *Hypnerotomachia Poliphili*? Dürer is known to have purchased a copy of it in Venice in 1506. Its dreamlike narrative, deliberately erudite as if to conceal all sorts of symbols, is given visual form in the extraordinary series of woodcuts in which rocks and vegetation provide the appropriate setting for a vision of ancient ruins in a way that has been suggested to have inspired Giorgione's *Tempest*. Leonardo was in Venice in the first months of 1500, soon after the publication of that book. And that was the time of another of his literary fabrications — the description of a feigned journey to the East, again a fiction in the form of letters with reports of such vividness of details and convincing rhetoric that a scholar such as Richter did not hesitate to take them seriously as evidence of Leonardo's visit to the Orient.

The designation 'Narrative Landscapes' applies to a series of red chalk drawings that can be shown to date approximately from the time of these literary fabrications. They are on the borderline between scientific observation and fantasy, as best shown by the celebrated view of a storm breaking over a valley (4). They appear to be nature studies and yet no convincing identification of the site represented has so far been offered. It is as if Leonardo already had in mind the background of a painting, such as that of the *Madonna of the Yarn Winder*, on which he was still working in 1501 (compare in particular 5 and 6). It is possible therefore that they are related to Leonardo's visit to the Alpine regions of the Venetia Giulia in 1500. Red chalk landscapes, made for strategic purposes, are found in Madrid MS. II of 1503-4. Again a stylistic link could be suggested with the present series, but it is hardly possible that 4 represents a Tuscan landscape, and so it might be safer to place it with the other drawings at the time of Leonardo's visit to the Veneto. But the problem must be kept open. In fact, it cannot be dissociated from that of the dating of the splendid views of trees on 7A and 7B.

[31]

With these drawings of trees Leonardo has focussed on one of the elements of landscape, and he has done so by aiming at the same type of information as conveyed by the illustrations to the fictitious story of the journey to the East. The miraculous drawings of a copse of birches is often called impressionistic. It is not. Branches and foliage are shown realistically almost as in a miniature, but with a vibrating quality in the touch of the chalk to produce the flickering effect of light on leaves moved by a breeze. The result is a hypnotic image, almost as hypnotic as that of flowing water. The drawing becomes the record of a visual experience that can be described in words, as Leonardo does so many times in the chapters of his Treatise on Painting.

4 *Storm over a valley in the foot-hills of the Alps* (Plate II)

Red chalk, 198 × 150 mm. (P 5 r; RL 12409)

Same paper, technique and style as the following 5 and 6. A date about 1500 is well in keeping with the style of the sketches in black chalk and pen and ink on CA, f. 145 v-a, the sheet with the description of the feigned journey to the East. Rather than a study for the background of a painting (it is sometimes related to that of the *Mona Lisa*), it would be suitable as an illustration to a note on painting, such as the one recorded by the compiler of the Treatise on Painting: 'In the middle of this chapter there was a foreshortened view of a city, on which rain fell, illuminated here and there by the sun...' (Lu 503, McM 552).

5 *Rolling hills and rocky mountain peaks*

Red chalk, 93 × 152 mm. (P 6 r; RL 12405).

Compare 4, to which see note. The diagonal lines of shading on the mountains on the right are slightly bent to follow form, and those on the trees in the foreground are slanting as if drawn with the right hand. Melzi's copies of Leonardo's drawings may occasionally show the same kind of descriptive touch, e.g. RL 12333 and 12361. But there is no reason to doubt that this drawing is by Leonardo.

6 *Mountain peaks, foot-hills and river in foreground*

Red chalk, 87 × 151 mm. (P 7 r; RL 12406).

The dolomitic character of the peaks points to the time of Leonardo's visit to the Veneto in 1500. The same relationship between river and rocky mountains, and even the same type of vegetation, occur in the background of the Montreal version of the *Yarn Winder Madonna*, a painting completed in 1501.

7A *Copse of birches* (Plate III)

Red chalk, 193 × 153 mm. (P 8 r; RL 12431 r).

Very similar trees are drawn, also in red chalk, on Paris MS. L, f. 81 v. This notebook dates from *c.* 1498 to 1502 and later. Some of its figure and technology studies can be shown to date from the early period; and to the same period can be attributed the drawings of trees. Compare the related notes on trees in Paris MS. M, a notebook of *c.* 1499-1500 (Richter, §§ 394-396). On the other hand, copses of trees are shown in the preceding drawings, in particular on 5 and 6. This, or a similar drawing, must have given Luini the idea for the background of his Leonardesque *Madonna and Child with a Lamb* at S. Vittore in Milan.

7B *A single tree*

Red chalk (P 8 v; RL 12431 v).

The note, given by Richter, § 456, explains how to represent trees and their foliage in relation to light. This shows that the drawings in the present series were possibly intended as illustrations to chapters for the planned Treatise on Painting. Same date as recto, to which see note.

THESE DRAWINGS are characterised almost exclusively by medium. They do not appear to be related to one another, and on the basis of style alone they seem to fall into two phases, a post-Anghiari period, *c.* 1506-8 and later (8-10) and a period that leads from the *St Anne* studies to the *Deluge* series (11-12). In fact, the last drawing in this series, 12, is on the same type of rough paper as the latest drawings of storms and cataclysms. In the first edition of his catalogue, Kenneth Clark singles out this drawing as 'interesting as being a study from nature preparatory to the fantastic landscapes'. It is certainly later than the Varese red chalk drawing of a St John the Baptist, *c.* 1513, to which it was related in the second edition of the catalogue.

The first drawing of the series, 8, is irregularly cut, thus suggesting that it was originally part of a larger sheet, possibly with manuscript notes. In style and technique it is consistent with a number of Anghiari studies. Compare the bold, however faint, sketches on RL 12338 r-v and the more delicate RL 12355. Two drawings of rocks and sea waves on Madrid MS. II, f. 41 r, are done with the same kind of chalk and are known to date in the autumn of 1504 when Leonardo was in Piombino. But a comparison with the even later Trivulzio studies would also apply.

Popham speaks of drawings in this series as having been made to illustrate or explain geological formations, and concludes: 'They have this in common with the vision of destruction, that they represent former catastrophic upheavals of the earth; they are petrified deluges'.

Convincing as this interpretation may be, it is misleading. It does not take into account the evidence of a transformation in progress as shown by the surge of water on 8 and by the explosion on 11. Before the close-up view of the explosion are placed the far views of mountain ranges, 9 and 10, which may thus appear in the wrong context. There is no doubt that they are in the same style and technique as the 'petrified deluges'. Nothing in these drawings of basaltic ranges stretching away in a sequence of rugged peaks is strangely formalised as in the later Deluge series. But the drawing of the explosion, 11, still convincing as it is in its disarray of shattered stones, and confusion of dust and smoke, already shows how the jets of water or dust at the bottom can be turned into the decorative pattern of schematised lines of force. This may also account for a certain theatrical emphasis in the frontality of the scenery, reminiscent as it is of Leonardo's studies for the stage set of Poliziano's *Orfeo* in the Arundel MS., a project dating *c.* 1506-8.

The 'petrified deluge' on 8 is sometimes dated as late as *c.* 1512-13, just before the drawing of the conflagration, 11. On the other hand, its connection with the well known texts on earthquakes in the Codex Leicester, which point to a post-Anghiari time, seems more substantial than a conceptual or stylistic affinity, and as such it can be taken to explain the silvery, smoky quality of the chalk as a reflection of the Trivulzio studies and of the studies of the human figure in heroic stance as adopted in the anatomical models from after 1506, e.g. RL 12630, 12631 & 12633 (K/P 89 and 90).

The compelling views of cities and villages at the feet of majestic mountain chains, 9 and 10, bring to mind immediately the background of the Louvre *St Anne*, which, however, does not include any representation of dwellings. And yet, the Burlington House cartoon

does seem to suggest the presence of houses in the Alpine setting of its background. The two drawings have the delicacy and precision of a fresh, direct record of actual views, and could appropriately illustrate an artistic theory as presented in several texts on landscape in the Treatise on Painting and in notebooks of *c.* 1508-10. In fact, 9 in particular could almost be taken as a reconsideration of the red chalk landscape on 4, further expanded to encompass a scenic effect as in aerial photography.

8 *Mass of stratified rock*

Black chalk, 163×201 mm, irregular (P 9 r; RL 12397).

A study from nature, possibly related to the background of the Louvre *St Anne*, but the touch of the chalk is closer to that of the post-Anghiari figure studies, e.g. RL 12630, 12631&12633 (K/P 89 and 90). For the peaks in the background, compare CA, f. 289 v-a, a sheet of geometrical studies with an anatomical study on the recto (f. 289 r-b) pointing again to a post-Anghiari period.

9 *Town in a plain, with mountain ranges*

Black chalk, 88×146 mm. (P 12 r; RL 12407).

A nature study, possibly for the mountain ranges in the background of the Burlington House cartoon or the Louvre *St Anne*. Related to the following drawing, to which see note.

10 *Foothills and mountain peaks*

Black chalk, 96×137 mm. (P 13 r; RL 12408).

Same style, paper and technique as the preceding drawing, to which see note. The chainlines in the paper are not in the same direction as those in that drawing, so the two fragments could not originally have been part of the same sheet. Similar peaks are shown on 8. The delicate touch might have been intentional, as suitable to a study in aerial perspective.

11 *Exploded side of a craggy mountain*

Black chalk, 178×278 mm. (P 14 r; RL 12387).

An unfinished copy by a pupil (possibly Cesare da Sesto) is on the newly revealed verso of a sheet in the Codex Atlanticus (f. 711 v in the new edition of the codex), on the recto of which (f. 263 v-b) is the drawing of a compass to draw conical sections and a note on the consumption or evaporation of the water of the Mediterranean Sea (MacCurdy, *Topographical Notes*), style and ductus suggesting a date of about 1510-15.

As a possible prelude to the Deluge series, this drawing is still closely related in style and character, as well as technique, to the preceding landscape studies. In fact, the type of rocks is as found in the background of the Louvre *St Anne*, and in spite of the formalised loops of smoke and the curling splash of water or dust, the drawing seems to be from nature. The doorway on the right may suggest the passage into a subterranean powder magazine, but the blast could be a natural occurrence.

12 *Cliff face with water below*

Black chalk on coarse cream paper, 145×161 mm. (P 15 r; RL 12390).

The touch of the chalk is the same as in the preceding drawing, and the subject suggests that this is a study from nature. And yet the paper is precisely as found in several sheets of the Deluge series, e.g. 46, and the type of rock is that which breaks down into square, basaltic blocks as seen on 59. It is also somewhat reminiscent of the rock formation that provides a seat to a St John the Baptist in a red chalk drawing formerly at Varese. This confirms that the Varese drawing dates from about 1513, shortly before Leonardo left Milan for Rome.

THE EIGHT plant studies in this series are rightly famous for their beauty and attention to detail, and as such they have been extensively studied both as works of art and as scientific illustrations. They have been reproduced innumerable times since their first public appearance at the Grosvenor Gallery Exhibition of 1878. But it was only in 1935, with the catalogue of Kenneth Clark, that they were all brought together and recognised as studies for the setting of *Leda*, the composition which had begun to shape up in Leonardo's mind at the time of the *Battle of Anghiari*, about 1503-4.

The mythological theme is approached from the start as a symbol of the generative forces of nature. This can be seen in the two finished drawings at Chatsworth and Rotterdam and in the preliminary sketches at Windsor. Leda is first shown in the kneeling attitude of a Venus Anadyomene, her voluptuous form coiling out of lush vegetation to expose the outcome of her union with the still enraptured swan — the four children tumbling out of their broken shells onto the comfortable bed of curling grasses. The composition is magnified to an eloquent close-up to suggest that it can be inscribed either in a circle or in a square, its open sensuousness further expanded by the assurance and elasticity of an emphatic pen work. The sketches on a sheet of Anghiari studies at Windsor, RL 12337 r, of about 1504, show how Leonardo is gradually bringing Leda up to her feet to dominate the landscape with her statuesque presence. And once the upright stance is reached, as shown in two other sketches at Windsor and in the copies, the spiralling movement is retained in the lively contrapposto and is still related to that of the surrounding vegetation. It was probably at the moment of preparing the final cartoon (possibly the one recorded in a drawing by Raphael) that Leonardo undertook a series of studies of the individual plants that he had carefully chosen as iconographically appropriate, particularly those plants which grow in the proximity of water. The earliest record of the lost cartoon in an inventory of 1614 refers to Leda as 'standing with a swan which plays with her by a swamp, with certain putti or cupids on the grass'.

Straightforward as their origin and function might be, these drawings elude a chronological focus, and as such they are just as problematic as many other Leonardo drawings. The first drawing, 13, the well known *Star of Bethlehem*, might have been intended for the grass in the first version of the kneeling Leda, and yet it could be a later drawing, the combined use of red chalk and pen and ink even suggesting an affinity with the water studies of *c.* 1508-10, e.g. 29A and 29B. It is possible that individual elements of the early composition were worked out in detail only later. In style and technique, however, these drawings are not at variance with the few sketches of plants and leaves in the Codex on the Flight of Birds, *c.* 1505-6, which also contains the sketch of an *écorché* leg which is in the same style and technique and which is related to the post-Anghiari series of anatomical studies.

All the drawings in this series have consistency of style, except that the last two, 19 and 20, are more openly descriptive as botanical specimens and are more in keeping with the character of the anatomical and technological studies of 1510 and later. The drawings characterised by a red preparation (14-17) again point to a post-Anghiari style and technique. They are only fragments of what originally must have been the sheets of a sketchbook.

[35]

This is made clear by the vertical fold in 15, which shows stitch holes. None of the drawings in the group can be taken to account for the missing portion on the left of 15, but it is possible that the notebook was not confined to plant drawings. The fragment RL 12583 A has a very similar type of red preparation. It represents the figure of a man bound to a tree trunk column as a St Sebastian, perhaps the study for one of the slaves in the Trivulzio Monument. And in fact style and preparation recall the anatomical models of *c.* 1508.

13 *A 'Star of Bethlehem' and other plants* (Plate IV)

Pen and ink over red chalk, 198 × 160 mm. (P 16 r; RL 12424).

Dated on the basis of style alone to the time of the later part of Anatomical MS. B, *c.* 1506-8. For the technique compare such Anghiari and post-Anghiari figure studies as RL 12625 r and 12640 r (K/P 95 r and 82 r). The penmanship in RL 12640 (K/P 82) r is in fact the same as in the spray of flowers at bottom right. A later date, *c.* 1513-14, is sometimes suggested by comparison with the style of the drawings in Paris MS. E, e.g. those on f. 42 v. This would explain the character of the curly leaves in their conceptual relationship with the movement of water in drawings from the time of the anatomical studies of *c.* 1513 (heart and blood), e.g. 31, to which see note. But there are earlier water studies showing the same combination of red chalk and pen and ink, e.g. those related to the Arno River canalisation project of *c.* 1503-4 in Arundel MS., f. 278 v.

Another study of the anemone plant at top right is on 18 below, in which the pen alone is used as if to prepare the drawing for the engraver.

14A *Flowering rushes*

Red chalk on red prepared paper, 201 × 143 mm. (P 17 r; RL 12430 r).

The drawing of a reedmace plant on the verso establishes a direct link with the studies for a kneeling Leda, such as the one at Rotterdam. Similar plants also appears in Cesare da Sesto's copy of the standing *Leda* at Wilton House.

14B *Study of a reedmace plant, with one seed vessel*

Red chalk (P 17 v; RL 12430 v).

See note to recto. The early collector's number ('126') may suggest that this side of the sheet was at one time considered the recto, but occasionally such numbers are also placed on blank versos, e.g. 15 v. The red preparation may also be taken to designate the recto.

This water plant is well appropriate to the marshy setting of Leda, and is often shown as an erotic symbol in the representation of female nudes, e.g. in a print of the so-called *Nymph of Fontainebleau* or *Diana* after a lost original by Rosso or Parmigianino. In a religious context it is symbolic of humility, and as such it appears in the foreground of Verrocchio's *Baptism of Christ*.

15 *Sprays of oak leaves and Dyer's greenweed* (Plate V)

Red chalk, touched with white, on red prepared paper, 188 × 153 mm. (P 18 r; RL 12422 r).

The heraldic character of the oak leaves and acorns (a well known emblem of the Della Rovere family) has brought about the suggestion that this drawing could have been a study for the garland in the lunettes above the *Last Supper* or for some portion in the decoration of the *Sala delle Asse*. Style and technique relate it to the series of plant studies for *Leda* and in fact an oak tree appears in the back of the Richeton version of the standing *Leda*.

The sense of plasticity achieved by the density of the red chalk lines of shading, deliberate contour line and highlights, is remarkably suggestive of bas-relief carving. This effect, however, was probably unintentional as I think that the contour line of the leaves and acorns was carefully reinforced by Melzi. Originally, it must have looked more like 17 below, which has also been touched up.

The verso is blank except for the early collector's number '126'.

16 *Branch of blackberry*

Red chalk, touched with white, on red prepared paper, 155 × 162 mm. (P 19 r; RL 12419).

Same style and technique as the preceding drawing, and possibly from the same sketchbook. Again a study for *Leda*, as shown by the presence of this plant in the Richeton version.

17 *Spray of a plant with cluster of berries*

Red chalk touched with white on red prepared paper, 143 × 143 mm. (P 21 r; RL 12421).

The note at top left reads: 'acero frutti / dj corallo —' (Acer: coral-like fruits). The plant in the drawing is

variously identified by botanists, e.g. as *Pyrus torminalis* by De Toni and as *Viburnum opulus* by Morley. The note refers to a plant of the *Aceraceae* family, possibly the *Acer platanoides*, a kind of maple. None of the known versions of *Leda* includes this plant. The leaf drawn in the Codex on the Flight of Birds, f. 15 v, is certainly of the same plant. The drawing was probably retouched by Melzi. Compare 15 above, to which see note.

18 *Study of two plants*: Catha palustris *on the left and* Anemone nemorosa *on the right*

Pen and ink over faint black chalk, 85 × 140 mm. (P 23 r; RL 12423).

Style and technique may suggest the time of the anatomical drawings of *c.* 1508-10, and yet this drawing cannot be dissociated from 13, on which the same *Anemone nemorosa* appears on top right. The same pen work, characterised by a tight cross-hatching, appears already in the post-Anghiari anatomical studies, e.g. RL 12625 r and 12624 v (K/P 95 r and 112 r), pointing again to the time of 13 above, *c.* 1506-8.

19 *Heads of two different types of rush* (Plate VI)

Pen and ink over traces of black chalk, 195 × 145 mm. (P 24 r; RL 12427).

These plant studies are turned into scientific illustrations by the accompanying notes, which are given in my Richter *Commentary*, Vol. I, p. 322. Their character suggests the type of drawing suitable for reproduction in copper engravings, in the same way

as are the anatomical studies of *c.* 1510. Compare also some of the horse studies for the Trivulzio Monument, e.g. RL 12303. A date *c.* 1508 at the time of the other plant studies for *Leda* is probably correct, and the type of water plant is iconographically appropriate to the subject. But a later date, *c.* 1513, cannot be excluded, style and handwriting pointing to the time of Paris MS. E. As in the following drawing, 20, Leonardo here stresses the element of flower and seed, thus suggesting the 'Discourse on herbs' planned as part of a discussion on painting on an anatomical sheet of *c.* 1513-14 (RL 19121 r, K/P 117 r). See also Richter *Commentary*, note to § 481.

20 *A long-stemmed plant*

Pen and ink over faint black chalk, 212 × 230 mm. (P 25 r; RL 12429).

This represents the popular Job's Tears (*Coix lachryma-jobi*), and like the preceding drawing it may be dated later than the plant studies for *Leda*. Clark had already suggested a later date, 'the long, free lines of the shading being rather like those of the head of Leda', i.e. RL 12518. The studies for the *coiffure* of Leda may well date from after 1510, possibly at the time of the water studies of *c.* 1513, e.g. 31 below. This plant study may indeed date from the same time, if not later, *c.* 1515. In fact, it is conceptually and stylistically related to Leonardo's architectural studies for a new Medici Palace in Florence of *c.* 1515 (CA, f. 315 r-b), and in particular to the drawings of archivolts made out of interwined branches which spring from tree-trunk columns.

Leonardo's views on landscape and his botanical studies are often reflected in the works of his pupils. These may be copies of his drawings or original studies done on his instructions.

When a pupil's drawing occurs on a sheet of Leonardo's studies, e.g. on 21A, it is relatively easy to date it. A date may also be suggested by the Leonardo style that it reflects.

Two of the school drawings, 22 and 23, have for a long time been attributed to Leonardo himself, and they are certainly worthy of him: the large sketch of a tree in black chalk and pen and ink on blue paper and the red chalk view of Amboise as seen from the window of Leonardo's bedroom at Clos-Lucé. Popp went as far as to say that the tree on 22 has the character of one of the heroes of the *Battle of Anghiari*, and dated it accordingly, *c.* 1503. The drawing can be attributed with reasonable certainty to Cesare da Sesto, and dated at least ten years later, *c.* 1513. Cesare da Sesto (*c.* 1477–1523), one of Leonardo's most gifted Milanese pupils, appears to have been working with him about 1510 and probably followed him to Rome in 1513. He was also associated with Peruzzi and Raphael. One of his drawings at Windsor, RL 12563, shows how a Leonardo idea could have passed on to Raphael, who in fact developed it in his celebrated *Madonna Alba*. The style of Cesare da Sesto's drawings is clearly recognisable on the basis of his sketchbook in the Morgan Library in New York, and of the sketch for the Pieve di Rosate *St Sebastian*, RL 063.

The view of Amboise, 23, shows the delicate and sensitive touch of the chalk with which many of Leonardo's own drawings have come to be associated. It is done with the right hand and it cannot be attributed to Leonardo, as some still do, on the assumption that Leonardo's working hand was recorded as being paralysed in 1517 and that in the last two years of his life he would have used his right hand. The paralysis had affected his right side and in fact there are scores of sheets of geometrical studies dated 1518 which show no failing in the use of his left hand. This drawing cannot be his, but is certainly evidence of the effectiveness of his teaching. It is almost certainly by Francesco Melzi, whose drawing in the Ambrosiana, dated 1510, shows how close he could come to Leonardo in handling the chalk. He was with Leonardo in France and inherited all his manuscripts and drawings.

The style of the View of Amboise is somewhat reminiscent of that of Cesare da Sesto's drawings, and in fact the drawing is much more spontaneous than any of the ones known to have been done by Melzi. At one time Kenneth Clark even suggested that it could be the work of Andrea del Sarto, who was in France in 1518 and whose landscape drawings in the Uffizi it recalls. Another authority has proposed a more convincing attribution to Andrea Solario.

The activity of Leonardo's studio and its impact on the Lombard school is far from being assessed, and much is to be expected from a systematic study of the drawings of Leonardo's followers. The present section provides evidence of some immediate response to Leonardo's teaching, but there are many more drawings that may still shed light on unexplored aspects of studio activities and the use of Leonardo's models and ideas.

21A *Sheet of miscellaneous studies and notes, including embracing nude couple, legs, and two landscapes* Pen and ink over black chalk, 241 × 170 mm. (P 32 v; K/P 119 r; RL 12641 r).

Leonardo's notes on water were added to a sheet on which a pupil, possibly Francesco Melzi, had already made a number of sketches. Melzi joined Leonardo's studio about 1508, and is known to have been employed to write letters for him. His, in fact, is the line at the centre, 'Mag^{ce} p̄r. hon.', which is the beginning of an address and which could well refer to Geoffrey Carles, or Karoli, vice-chancellor of Milan, and President of the Waters, the authority in charge of Milan canals (cf. Calvi, pp. 237, 263, etc.). This may provide a hint towards dating the sheet. It was about 1508 that Leonardo was given the rights to twelve ounces of water on the Navilio as a present from Louis XII; and only after that time would he have had reason to correspond with President Carles, especially because of a controversy concerning his rights on that property.

The figure studies may also be attributed to Melzi, possibly as first ideas for his *Vertumnus and Pomona* at Berlin, in the background of which is a rocky landscape very close in character to the two landscapes on this sheet. In their weak and untidy line, these drawings are well in keeping with the roughness of Melzi's known pen sketches, e.g. RL 12393 (P 33 r). Like Leonardo, however, he was also able to use the pen and the chalk to draw with great precision and delicacy. Compare 23 below.

21B *Sheet of miscellaneous studies and notes, including nude figures in action. In the centre, the stalk of a plant topped by an oblong flower*

Pen and ink, with traces of black chalk (P 32 r; K/P 119 v; RL 12641 v).

Leonardo's notes here are transcribed and fully discussed in the Anatomical Corpus. See also note to recto. The small plant study is certainly by Leonardo, showing the style of the late drawings in Anatomical MS. B. No such plant appears in any of the known version's of *Leda*, nor in the second version of the *Virgin of the Rocks*.

22 *Study of a tree, possibly a fig tree*

Pen and ink over black chalk on blue paper, 392 × 265 mm. (P 34 R; RL 12417).

This drawing is often attributed to Leonardo. The blue paper is the same as that employed in Leonardo's Anatomical MS. C II of 1513, and even the pen work resembles closely that of Leonardo's late anatomical studies. But it cannot be his. It shows the characteristic touch of Cesare da Sesto as seen, in particular, in a drawing of *Adam and Eve beside the Tree* in his Morgan sketchbook. This could well be, in fact, a finished study for the tree in that drawing. Compare also the tree in Cesare da Sesto's drawing of a *St Sebastian* at Windsor, RL 063.

23 *The Castle of Amboise seen from Clos-Lucé*

Red chalk, 133 × 263 mm. (P 35 r; RL 12727).

If this was done, as seems possible, during the last three years of Leonardo's activity in France, it could be attributed with reasonable certainty to Melzi, who is known to have followed him there. On the other hand, the watermark (eagle in a circle) is the same as that of some of post-Anghiari figure studies, e.g. RL 12631 & 12633 (K/P 89). This could hint at an earlier date, *c.* 1508. Luisa Cogliati-Arano has attributed this drawing to Andrea Solario, who was in France precisely at that time.

THIS SERIES is named after the red ground preparation of the paper for the use of red chalk. The first drawing, 24, is dated by Leonardo's own reference to the fires lit by the Swiss troops near Desio in their retreat from Milan on 16th and 18th December 1511.

Drawings in the same technique include two sheets of anatomical studies, one at the British Museum and the other at the Ambrosiana, which in turn are related to a well known sheet at Windsor, RL 12625 (K/P 95). All these drawings contain detailed studies of human legs, and the first drawing in the present series, 24, must have been initially intended for such anatomical studies, as shown in fact by the details of a leg and a foot lightly drawn on it the other way of paper. Leonardo worked on anatomy with particular intensity about 1510-11, but it is possible that a number of his anatomical studies were already done in this characteristic technique a few years earlier.

Perhaps the most spectacular example of the use of this technique is represented by the large drawing, formerly at Varese, of a St John the Baptist seated in a landscape of rocks and vegetation. And the Ambrosiana sheet with a study for the right foot of Pomona in Melzi's painting at Berlin was possibly intended for another of Leonardo's red landscapes. In fact a hint of such landscape is visible by rotating the sheet 90° to left. Leonardo used the verso of the sheet for red chalk notes on landscape which are related to the notes on painting in Paris MS. G. It appears that as Leonardo dismissed the sheet Melzi took it over to use the available red preparation for the study of a foot.

The fires lit by the Swiss near Desio and portrayed on 24 can be taken as indirect evidence of the fact that Leonardo was not in Milan in December 1511, but more probably at Vaprio, and therefore at a vantage point from which to follow the retreat of the Swiss troops. It is also possible that the other drawings of the series were done a few months earlier, at the time of Leonardo's survey of the course of the Adda River upstream to Lake Como, perhaps in connection with canalisation projects as mentioned in his manuscripts after 1508. The rocky bank of a river shown on 25 might well refer to the Adda River above Vaprio and Trezzo on the way to Lecco. And in fact the mountain chains as represented on 26 are characteristic of the rugged ridge overlooking Lecco, including the rocky mountains called Resegone, as possibly represented on RL 12411 & 12413 (P 41 r). This is the part of Lake Como out of which the Adda flows to become a river again after having entered the lake at the north end in the locality of Colico. The delta shown on 27 might well be a view of the Adda as it enters Lake Como.

The mountain chains on 28 might be again a view of the landscape of Lake Como, and not of the Monviso or Monte Rosa as is sometimes suggested. Of course, the possibility that some of these landscapes could refer to the Alps in Piedmont cannot be dismissed, since the date 1511 for this series is the same as that found in Paris MS. G in relation to a record of localities in Piedmont. It is true that a drawing such as 28 gives the impression that only the peaks of huge mountains are visible as they emerge from banks of clouds. And yet the original shows clearly the plain from which they rise, in the same way as do the mountain chains on 26. The geological observations in the accompanying notes on 26 seem to suggest a type of mountain as found in the proximity of a lake rather than a major Alpine chain completely devoid of vegetation. Because of the notes on 26 and 27 these drawings

can thus be taken to be related to texts in the Treatise on Painting which show the same literary style and which are gathered under the general title *Of the Shadowed and Bright Parts of Mountains* (Lu 791-808).

24 *Drawings of two fires, one dated 16th and the other 18th December 1511*

Red chalk on red prepared paper, 147 × 236 mm. (P 36 r; RL 12416).

As Leonardo's notes in red chalk had begun to fade, Melzi transcribed them in pen and ink. They record the historical event of the retreat of the Swiss troops after their unsuccessful attack on Milan on 14th December 1511. The event is described in detail by the chronicler Prato, who mentions the fires portrayed by Leonardo. See Richter *Commentary*, note to § 1022. According to Leonardo, both fires were lit at the same hour of the day, at 'hore 15', i.e. about 9 AM.

The notes suggest that Leonardo executed the drawings as he was watching the occurrence. This would imply the use of the same sheet on two different occasions, as a photographer would pick up the same camera two days later. It is more probable that the two drawings were done from memory, possibly soon after the second event. This would also explain why Leonardo used a sheet on which he had already sketched the anatomical details of a leg and a foot.

Leonardo's interest in the effect of smoke in a landscape is shown by his notes on painting in Paris MS. F, c. 1508. Compare also the note headed 'Thick smoke produced by green wood is like clouds' on the verso of the 'Foglio Resta' at the Ambrosiana, a sheet of the same red series dating from the same time. (Richter *Commentary*, Vol. I, p. 306.)

25 *Quarry beside a river*

Red chalk on red prepared paper, 133 × 239 mm. (P 37 r; RL 12415).

The upper part on the right is too slight for interpretation. It appears at first to continue the rocky cliff of the quarry, and yet the indication of an arcaded structure may suggest that the area is open to a view into the distance, so that the roots of the tree in the centre would correspond approximately to the left side of the opening. If so, the arcaded structure would refer to the opposite bank of the river which runs behind the quarry. This type of structure is still seen at Vaprio as a retaining wall for the canal running below the Villa Melzi. Compare also the sketch of a villa on CA, f. 153 r-e.

The small trees with their exposed roots are the same as seen in the Adda River Series below, in particular on 36 and 37. Finally, the canal boat is the same as that depicted on an early sheet of the Codex Atlanticus (f. 7 r-b, c. 1483-5), and said to be 42 braccia long, approximately 25 metres. The proportions between men and boat in the present drawing show that the boat can hardly be more than 12 metres. It is probably the same boat as that shown in the Adda landscapes 33 and 34 below.

26 *Two mountain ranges, with notes* (Plate VII)

Red chalk on red prepared paper, 158 × 230 mm. (P 38 r; RL 12414).

The character of the rocky mountains suggests the landscape around Lake Como, north of Lecco. The observations on the kinds of vegetation as determined by the nature of the terrain (Richter *Commentary*, Vol. I, p. 318) are developed in notes on painting which are known only in the copies in the Treatise on Painting, e.g. Lu 804-806 (McM 837-839).

27 *Swampy plain seen from above, with notes*

Red chalk on red prepared paper, 150 × 235 mm. (P 39 r; RL 12412).

Like the preceding drawing, this may also refer to Lake Como, possibly to the northern part of it where the Adda River enters the lake. The notes on the colour of the water, foam and gravel (Richter *Commentary*, Vol. I, pp. 317-18) were also intended to be developed into chapters of the Treatise on Painting. Compare Lu 507 and 508 (McM 524 and 525).

On the newly revealed verso (not exhibited) is a slight sketch by Leonardo of an architectural structure, possibly the wooden frame of a building with tent-like roof. This may refer to the water-meter designed by Leonardo for Bernardo Rucellai in 1510-11. Cf. *Master Drawings*, XVII, 1979, pp. 24-28.

28 *Snow-covered mountain peaks*

Red chalk, heightened with white, on red prepared paper, 105 × 160 mm. (P 40 r; RL 12410).

This is often referred to major Alpine ranges such as those which include the Monte Rosa and the Monviso. Leonardo himself mentions 'Monboso', i.e. Monte Rosa, as a mountain that he had climbed. See Richter, § 1060. But these views are more probably of the mountains around Lake Como; in fact they include a slight indication of the foot-hills from which the mountains rise. Compare 26.

41

WATER STUDIES

EXTENSIVE NOTES on water are found in Leonardo's earliest manuscripts, in fact in the same manuscripts in which he had begun to collect notes for a book on painting, that is, Paris MSS. A and C, which both date from about 1490. Both subjects were again associated in notebooks of a later period, from after 1508, e.g. Paris MSS. E, F, and G, as well as the lost *Libro A*, which was of identical format. And of course, in notebooks of the intermediate period, from about 1495 to 1505, the notes on the nature of water and canalisation always come as a counterpart to observations on painting, especially landscape and atmosphere. And so it is easy to understand that it is painting that is behind Leonardo's conception of the earth as an organism similar to the human body.

The chronology of Leonardo's manuscripts shows that whenever Leonardo undertook anatomical studies his mind was about to move into the problem of the earth's structure. Chapters on the formation of mountains in the Treatise on Painting (Lu 804–806, McM 837–839), which are from manuscripts no longer in existence, have the same literary style as the anatomical manuscripts of *c*. 1508–10. And the style and character of the water studies in this series are the same as in the conceptually related studies of the movement of blood in the late anatomical manuscripts. It is therefore appropriate that a human figure should be juxtaposed to water vortices on 32A. This sheet well reflects the contents of Leonardo's notebooks both early and late, in that discussions on water and notes on painting are always concurrent, although there is no indication that the two subjects had been intended to be linked together as if to suggest that a painter could profit from a knowledge of the nature and movement of water.

The painter's ability to portray water and the effect of transparency in viewing objects through it was taken by Leonardo as one of the major arguments in advocating the superiority of painting over poetry and sculpture. Thus he would speak of 'places adorned and delightful — transparent waters through which are seen the green depths of their courses, waves that play over meadows and small stones and grass, mingling with playful fish and similar details' (Lu 20, McM 29). These observations may well be of a late period, at the time of the planned garden for the house of Charles d'Amboise in Milan, *c*. 1508–10, which was to have little brooks with the herbage cut frequently 'so that the clearness of the water may be seen upon its shingly bed' (CA, f. 271 v-a, Richter *Commentary*, Vol. II, pp. 29–30).

The representation of transparent water, which Lomazzo mentions as one of Giorgione's specialities, attracted Leonardo especially in his late period, as hinted at in the foreground of his Burlington House cartoon. This is confirmed by a chapter in the *Paragone*, which was copied from the lost *Libro A* and which speaks of the sculptor's shortcomings as including the inability to portray 'the small pebbles of various colours beneath the surface of transparent waters' (Lu 41, McM 57).

The movement of water and wind as visualised by the debris, dust and smoke mingled together, should be the painter's concern, and yet it seems that Leonardo himself hesitates to draw a sharp demarcation line between the painter's interest in the effects and the philosopher's preoccupation with the causes. Indeed, Painting is Philosophy (Lu 9, McM 8). And so a text on the Deluge on a late sheet of the Codex Atlanticus, f. 79 r-c, so closely

related to 42 and 43 below, ends with the remark: 'And the rest of this subject will be treated separately in the Book on Painting'.

As Lord Clark has repeatedly pointed out, the drawings in the present category of water studies can be considered as the forerunners of the Deluge series. Their quality of line conveys an effect of impetuous flow, but one that can be analysed in its minutest components — lines of force that circle around and penetrate one another to generate bubbles of escaping air, themselves recurring in a circle of glittering rings on the turbulent surface. An incredible feat in draughtmanship, which achieves an unprecedented effect of plasticity as of a volume of frozen energy reminiscent of the variegated stones of geological ascent that had so much fascination for Leonardo at this time.

Nowhere in the Treatise on Painting is there to be found a discussion of water currents and water eddies — nothing in fact of the equation between water and wind as frequently postulated in Leonardo's late writings along with a visualisation of lines of force in drawings of atmospheric activities — the Deluges — which came to be turned into symbolic landscapes. One is therefore left with the question as to whether Leonardo ever conceived of a painter who would approach natural forms without a knowledge of their structure. The answer, of course, is that it is impossible to speak of his drawings not as scientific diagrams, and of his scientific diagrams — at times of exhilarating complexity — not as works of art.

29A *Sheet of studies of water passing obstacles and falling into a pool, with notes* (Plate VIII)

Pen and ink over traces of black chalk, 298 × 207 mm. (P 42 r; RL 12660 v).

This is stylistically and conceptually related to Leonardo's studies on the movement of blood and on the movement inherent in vegetable growth, as best exemplified by the 'Star of Bethlehem' on 13.

The series to which this sheet belongs is chronologically parallel to the compilation of Paris MS. F, *c.* 1508-9. The schematised character of these drawings takes up an almost heraldic connotation, as if to suggest a symbolic link with the emblems on RL 12700, which date from the same time and which present the theme of the desire to serve in the motto *sine lassitudine* and in the representation of a lily (the *fleur-de-lis* symbolic of the King of France) being nourished by a continuous jet of water — one of the charming vignettes showing a landscape of rocky peaks in the background. Indeed, this series of water studies, which has been viewed as a prelude to the Deluge series (Clark), paves the way to the conception of landscape as symbolic form. Thus the emblems on Arundel MS., f. 225 r, are juxtaposed to a study of swirling water which is related to the present series and to a study in Paris MS. G, f. 90 v. See Richter *Commentary*, Vol. I, pp. 313 and 394.

29B *Studies of water impeded by an obstacle, with notes*

Pen and ink over chalk. (P 42 v; RL 12660 r).

The small topographical sketch at bottom right refers to a town in Switzerland, Arosa, which is immediately north of the Splügen Pass. The accompanying note on flooding suggests that Leonardo had been there.

The notes and drawings in the upper part of the page show that they have in common with many pages of Paris MS. F a characteristic double process of compilation. In fact, the red chalk is used not only as a preparation for the pen and ink drawings but also to write the notes, which are then gone over, letter by letter, with pen and ink. This is particularly evident on 30. Leonardo seems to have adopted this technique from *c.* 1506 to 1512. It is the counterpart to his drawings for the Trivulzio Monument, e.g. RL 12356 r, and to the drawings of plants for *Leda*, e.g. 13 — a technique which deceives the eye with a fleeting impression of transparency, as if intended to convey the effect of depth and roundness.

30 *Sheet of water studies and notes on atmosphere*

Pen and ink and red chalk, 205 × 203 mm. (P 44 r; RL 12661).

This was originally joined to RL 12664 r, and as such it is reproduced in the facsimile edition of Leonardo's landscape studies at Windsor. The main drawing at top right shows a proliferation of bubbles on the surface of swirling water. Leonardo repeatedly refers to these bubbles as 'sonagli', thus attaching a musical implication to the image of bubbling water.

31 *Sheet of water studies, with notes*

Pen and ink and red chalk on coarse yellowish paper, 268 × 184 mm. (P 47 r; RL 12662).

Similar actions are illustrated on Paris MS. F, e.g. f. 72 r, thus suggesting the same time as the other studies in this series. But paper and style point to a later date, *c.* 1513, at the time of Leonardo's anatomical and architectural studies at Vaprio, which are characterised by the same type of coarse yellowish paper. This paper is also employed in some of the studies for the Trivulzio Monument, e.g. RL 12356.

The bubble effect in the upper part, the other way of paper, shows the same delicacy and vividness of touch as the Adda River landscapes, e.g. 33 and 35. The pouring water in the drawing at the bottom is shown as matter solidifying, with the same deliberate lines that characterise the water studies in Paris MS. E, f. 42 v, *c.* 1513-14. And its cross-hatching makes it curiously similar to the drawing of the neck in the study of Leda's head on RL 12515.

32A *An old man in profile to right, seated on a rocky ledge; water studies and a note* (Plate IX)

Pen and ink, 154 × 216 mm. (P 48 r; RL 12579 r).

These water studies are somewhat later than those on 29A, which they resemble closely. The preceding drawing could be dated *c.* 1513 for the reasons given in note to it, and the same date may apply to the present drawing. Studies of swirling water of the same character and style are on a sheet of the Codex Atlanticus, f. 395 r-b, which contains studies of architecture and flight of birds, on the same paper as the preceding drawing. The architectural studies have been identified as pertaining to a project to enlarge the Villa Melzi at Vaprio d'Adda, and the studies on the verso of the present sheet can be reasonably recognised as details of the superimposed orders in that building. The observation on the resemblance between the movement of hair and that of water (Richter, § 389) is aptly illustrated by the representation of hair in the Louvre *St John*.

The figure of an old man is often considered as an idealised self-portrait, but this is unlikely. It certainly portrays a man much older than 61, Leonardo's age in 1513.

32B *Architectural studies*

Red chalk. (P 48 v; RL 12579 v).

See note to recto.

THE ARCHITECTURAL studies on the verso of the last drawing in the preceding category, 32, have been tentatively related to Leonardo's project of enlargement and systematisation of the Villa Melzi at Vaprio d'Adda, a project that can be dated *c.* 1513 on the basis of related material in the Codex Atlanticus and in the anatomical Corpus at Windsor. There is no way to ascertain whether the project was prompted by a commission or whether it was an idea originating from conversations with members of the Melzi family while Leonardo was a guest in their villa some time before he moved to Rome in September 1513. It was about 1508 that Francesco Melzi, aged 17, entered Leonardo's studio in Milan. His father, Gerolamo, was a member of the Milanese senate and must have known Leonardo since the time of the Sforza government, before 1499. The villa at Vaprio was built in 1482, as shown by the inscription on a tablet still in place. It is a curious fact that in the eighteenth century the style of its architecture was taken as evidence of Leonardo's authorship and therefore as proof of his presence in Lombardy as early as 1482. Evidence discovered later proved the date to be correct, but the attribution of the building to him had to be discarded.

Vaprio is located about twenty miles east of Milan, and the Villa Melzi stands on the right bank of the Adda River, with a canal running between the Villa and the river. Later views, such as Bellotto's in the eighteenth century, show that the landscape remained for a long time much as it was in Leonardo's day. In fact, it was still the same, both in general appearance and in details, as shown on 33 and 34, including the ferry-boat between Vaprio and Canonica di Vaprio, which could be seen from the terraces of the Villa Melzi and which can be recognised in 35.

The present category is made up of quick and yet detailed notations, all equally impressive and equally powerful. The small fragment 36, sometimes designated as 'Trees at Vaprio', is a miracle of miniaturistic precision, vibrating with energy in every touch of the pen as if to convey the idea that vegetable life has succeeded over a rugged terrain, which is sliced open as in an anatomical dissection to reveal the rocky stratification lightly covered by humus, the roots of the gnarled, dwarf trees finding their way through crevices or hanging exposed as the erosion progresses. It is an image that can be enlarged to the size of a cinema screen only to enhance the visual impact of its perfectly balanced composition and the pervading sense of the organic. Conversely, the subsequent drawing, 37, can be reduced to the size of this small fragment without losing any of its brilliancy and appeal, because it is the outcome of the same impulse of the pen and because Leonardo's mind is set at the same thought on the working of nature. A measureless past comes to be measured through the diagram of a rock structure that flakes off and disintegrates to illustrate a mutation process which is symbolic of the living earth. One can sense that symbolic landscapes, leading to the final vision of storms and deluges, are gradually taking shape in Leonardo's mind.

33 Bird's-eye view of a river valley with canal

Pen and ink over black chalk, 85 × 160 mm. (P 49 r; RL 12398).

This and the following drawing are views of the Adda River at some point between its exit from Lake Como and the stretch between Trezzo and Vaprio. A topographical representation of the area is given on CA, f. 335 r-a, a sheet datable *c.* 1510 or slightly later, which shows clearly the canal seen in both drawings. The rapids are particularly strong and dangerous at the Tre Corni, the locality so designated

There are records of one such event which occurred in the Alps near Bellinzona in 1513 and again in 1515, when Leonardo was either in Milan or at Vaprio, and which might indeed have had a bearing on his conception of the Deluge series. But whatever the motivation, historical or natural, the Deluge series remains an extraordinary document of the working of Leonardo's mind at the end of his life.

38 *Allegory of river navigation* (Plate X)

Red chalk on brownish-grey paper, 170 × 280 mm. (P 54 r; RL 12496).

A famous drawing. The boat, the mast as a tree, the pilot (a wolf or more likely a dog), the compass, the eagle and the globe, have each been interpreted in different ways as being symbolic representations of the Papacy, the Emperor, the Power of France, the Medici, Sforza, or Borgia families. The numerous interpretations, as reviewed in the *Windsor Catalogue*, have failed to note that the setting is a river, one which is characterised by an impetuous course and by steep rocky banks. Such was the Adda River, the canalisation of which was financed by Francis I in 1515. The drawing may well reflect an aspect of French politics towards the Milanese, as hinted at in Thomas More's *Utopia*. See Richter *Commentary*, Vol. I, p. 379.

The style is as expected in Leonardo's latest drawings. The closest analogy is provided by a drawing in Paris MS. E, f. 42 v, in which water waves and wind currents are drawn with a similarly deliberate, lifeless line. This would suggest a date about 1513-14. The reference to Francis I's financing of the Adda canal project would point to an even later date, *c.* 1515-16. This would explain the enigma of the Turin self-portrait, which is in the same style and technique as the present allegory and which would therefore represent Leonardo at the age of sixty-four.

39 *Standing woman in landscape* (the 'Pointing Lady')

Black chalk, 210 × 135 mm. (P 55 r; RL 12581).

This study is usually considered to represent one of the masqueraders drawn by Leonardo late in life. But unlike those drawings, it includes a landscape setting. It could be argued that this is a stage simulation, but there is nothing artificial in it, and the foreground is directly related to the background by the stream of water that runs into the depth of space.

The figure owes much of its appeal to the mastery with which her garment is represented. The complexity of its folds is evocative of the turbulence of wind and water currents as in the Deluge series. The enticing posture as revealed through the light drapery is inspired by the Antique and aptly illustrates Leo-

nardo's note about imitating 'the Greek and the Latins in the manner of revealing limbs when the wind presses draperies against them' (Lu 533, McM 573). Thus this figure comes to be intimately related to the landscape not only by the emphatic gesture pointing into the distance but above all by the suggestion of the wind against which she stands.

40 *Wind storm and flood over a bay with castle and viaduct*

Pen and ink over black chalk on coarse brown paper, 163 × 206 mm. (P 56 r; RL 12401).

The unfinished area of the drawing may offer the key to an explanation of the Deluge drawings as a form of symbolic landscape. The enigmatic objects among the loops of rain and windstorm appear to be casts of drapery attached to staffs which are topped by a cap and a nob. They are carefully studied on a sheet of the Codex Atlanticus (f. 317 r-a), which must have been a fragment of a Deluge drawing. In the present drawing, on the right, the slope of the high mountain is shown to have plateaux at different levels; they look somewhat like circular platforms at the centre of which a staff had been fixed. It soon becomes evident that the strange objects are military tents of a type often represented in scenes of Roman history, e.g. in Raphael's *Allocution of Constantine* in the Vatican. As they become the prey of the unbridled forces of nature, they can be taken to show that human power and pride are of no avail against the fury of the elements. The allegory may well have been suggested by an actual occurrence that took place in the mountains of Bellinzona in 1515, as recorded by Giovio and other historians. See Richter *Commentary*, note to § 1092. This is therefore an appropriate overture to the Deluge drawings, which show the same style and technique.

41 *Storm-clouds over river or lake and trees*

Pen and ink and brown wash over black chalk on coarse brownish paper; a large spot of red chalk, probably an accidental offset, in the middle, 156 × 203 mm. (P 57 r; RL 12379).

The paper is similar to that of the preceding drawing. In addition to pen and ink, a brown wash is used

as on 42, which is in turn related to a sheet of Deluge studies in the Codex Atlanticus, f. 79 r-c.

This could well refer to the Bellinzona disaster of 1515 as suggested by the position of the two hills and the lake behind. See note to the preceding drawing.

42 *Mountain range burst open by water, the falling rocks producing enormous waves in a lake; with a note* (Plate XI)

Pen and two inks (black and yellow) over black chalk, with wash, on coarse brownish paper, 162×203 mm. (P 59 r; RL 12380).

The note on rain along the top margin is given in Richter *Commentary*, note to §§ 479-480.

This is perhaps the most famous drawing of the Deluge series, and perhaps the least understood. The historical accounts of the Bellinzona disaster of 1515 (see note to 40 above) speak of mountains collapsing and the effect of dashing water overthrowing retaining walls and submerging whole towns. In CA, f. 79 r-c (Richter, § 610), which contains preliminary studies for the present drawing, Leonardo writes an outline of the elements of the Deluge as elaborated in the descriptions on 50 A-B, and expands upon the motif of the mountain falling on a town to conclude 'the rest of this subject will be treated in detail in the Book on Painting'. The Treatise on Painting as compiled by Melzi contains only occasional references to the representation of storms. It is possible that Leonardo had intended the Deluge drawings as illustrations to notes on painting. As symbols such as wind gods or military tents are introduced (compare 40 and 49), these drawings could be turned into moralising *istorie* in the traditional sense. Hence the need to include them in the repertory of suggestions for compositions in a planned book on painting.

One cannot but be puzzled over such a formalised representation of a natural disaster. Thus Clark can speak of the scientific side of Leonardo's character as being 'ashamed of anything so obviously untrue to natural appearances'. On the other hand, it was Leonardo's aim to reduce natural truth to a scheme that could be readily perceived as a geometrical diagram.

43 *Deluge over hill-top city*

Black chalk on coarse cream paper, 158×210 mm. (P 60 r; RL 12385).

The subject of the flood assailing a town might have been inspired by the reports of the Bellinzona disaster of 1515. See note to 40 above. The scenery is curiously reminiscent of the bird's-eye view of Pisa in the Map of Tuscany, RL 12683, with the fortress of La Verruca similarly located on a rocky mountain in the foreground. The huge waves in the background would then proceed from the sea. But the analogy is probably accidental.

44 *Town at centre of vortex*

Black chalk on coarse cream paper, 163×210 mm. (P 62 r; RL 12378).

The subject of a mountain falling on a town is discussed on a sheet of Deluge studies in the Codex Atlanticus (f. 79 r-c; Richter, § 610). The description is remarkably close to this drawing and is illustrated by sketches of the same style and technique as 42. The sheet of the description can be dated after 1515 because it contains a reference to the shipment of artillery from Venice to Lyons at the time of Francis I's expedition to Italy in 1515. (See Richter *Commentary*, note to § 610.) These connections show that all the drawings in this series are from the same time and for the same purpose, regardless of the different techniques employed. Thus the town on the present sheet could be the same as that shown on 43. The view-point is slightly changed, but the fortress is still hinted at bottom right.

45 *Deluge and thunderstorm over wooded country*

Black chalk on coarse cream paper; an accidental stain at bottom right, 165× 204 mm. (P 64 r; RL 12384).

Here Leonardo moves to the close-up of a wood set on fire by lightning while the windstorm dashes down on the hillside. He has left the destroyed town behind as if to survey the neighbouring hills as the Deluge moves around.

46 *Deluge over falling trees*

Black chalk on coarse cream paper, 161×210 mm. (P 65 r; RL 12386).

The Deluge progresses with sustained impetus. The close-up on the inevitable fate of the trees becomes a visual comment to a statement on Paris MS. F, f. 37 v, c. 1508-9: 'I have seen movements of the air so violent as to carry away and strew in their course immense forest trees...' (Richter, § 1338).

47 *Deluge at sea*

Black chalk on coarse cream paper, 158×210 mm. (P 66 r; RL 12383).

The Deluge has succeeded in its destructive purpose. All the land is covered by water, and the blasts of wind are represented in a way that recalls Lucretius,

De rerum natura, I, 290-294: '...they push things before them and throw them down with repeated assaults, sometimes catch them up in curling eddy and carry them away in swift-circling whirl'.

48 *Sheet of miscellaneous studies of destruction falling on the Earth, with notes* (Plate XII)

Pen and ink over traces of black chalk on coarse brown paper, 300 × 203 mm. (P 70 r; RL 12388).

The notes, given by Richter, § 477, are on the colour effects in clouds and are unrelated to the allegorical drawings on the page.

Again a page that eludes the iconographer. The presence of skeletons rising from the earth as in Signorelli's *Resurrection* at Orvieto, and the destruction raining from Heaven as in a *Dies Irae*, are all too obvious ingredients of Christian eschatology. But how to explain the collapsing castle of typically Renaissance forms, with its corner towers and crenellation? How to explain the impassive, burning giant? How to explain the volcanic crater neatly sliced in cross-section as in a view of Dante's *Inferno* in the 1506 edition of the *Divine Comedy*? And finally, how to explain the fiery sphere in the sky? It is not enough to read in Matthew, XXVII, 51-53, 'and the earth did quake, and the rocks rent; and graves were opened', to conclude that Leonardo wanted to illustrate the gospel. Any account of an earthquake could have contributed to his apocalyptic vision.

Ductus and style suggest a very late date, after 1517, at the time of Leonardo's interest in clouds and horizon as subjects for his planned Book on Painting.

49 *Hurricane over horsemen and trees, with gigantic water spouts*

Pen and ink over black chalk, with touches of wash and traces of white, on grey washed paper, 270 × 410 mm. (P 68 r; RL 12376).

The preparation of the paper, the touch of the pen and the colour of the ink and wash, all point to the French period, after 1517. Style and technique are fully discussed in the forthcoming Corpus of Leonardo's landscape studies at Windsor.

The enigmatic subject must remain a challenge to the iconographer. It includes traditional symbols such as wind gods in the tempestuous sky, a motif already advocated by Alberti and introduced in Uccello's *Deluge*. The episode at bottom right is particularly puzzling, in that the only time a horseman does not look like a giant putto is when he looks like a woman! In fact, the one on the left reminds us of such female figures with fluttering garments as the 'Pointing Lady', 39, or better still the 'Dancing Maidens' at Venice. And the horses are indeed of the same character and style as those on RL 12331, a sheet now recognised as dating from the French period.

50A *Sheet of notes on how to represent the Deluge, with marginal illustrations*

Pen and ink, 304 × 213 mm. (P 67 r; RL 12665 v).

Both sides of the sheet are filled with notes on how to represent a Deluge. They are given by Richter, §§ 608-609. For related texts in the Codex Atlanticus, which date from the same time, after 1515, see Richter *Commentary*, notes to §§ 607-611. Such descriptions were intended for the projected Book on Painting, as stated by Leonardo himself. See note to 42 above. The compiler of Leonardo's Treatise on Painting, Francesco Melzi, failed to include these late texts, although he certainly knew them since he refers to them in a marginal note to an early chapter on how to represent a storm (Lu 68, McM 280): 'Here I recall the admirable description of the Deluge given by the author'.

The marginal drawings approach the character of line illustrations that can be easily reproduced in wood-cut. They are the equivalent of the small drawings and diagrams in the Treatise on Painting.

50B *Sheet of notes on how to represent the Deluge, with marginal illustrations*

Pen and ink. (P 67 v; RL 12665 r).

See note to recto. The last illustration, at bottom right, is inscribed: 'ōde del mare dj pionbino / tutta dacqᵃ spumosa' (Waves of the sea at Piombino, all of foaming water). As this was written late in life, possibly in France, Leonardo is here recalling his visit to Piombino in October 1504. He thinks, in retrospect, of the sea waves splashing against the rocky shore of Piombino, as portrayed on Madrid MS. II, f. 41 r. Compare also the sketch on Paris MS. L, f. 6 v, which is inscribed: 'Made by the sea at Piombino'.

PLATES

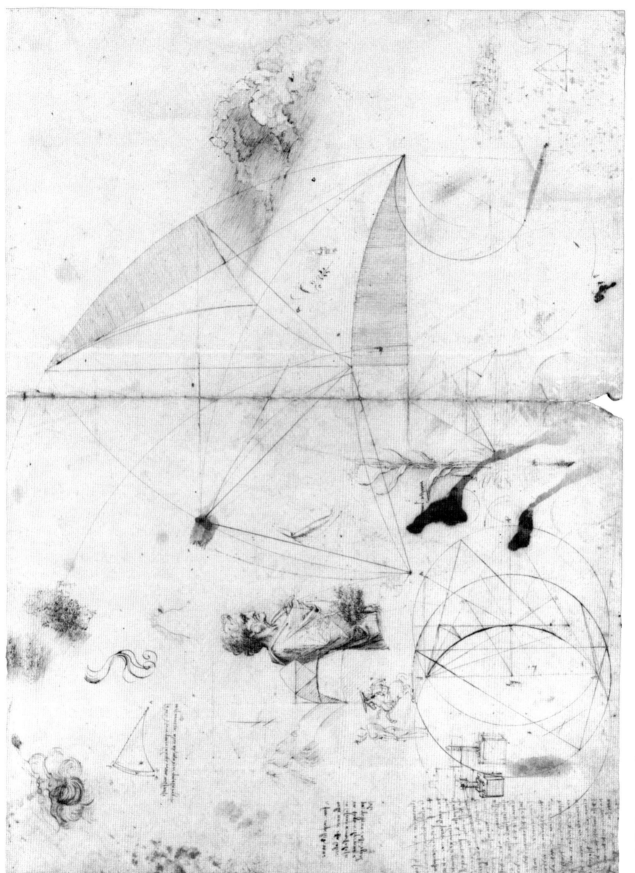

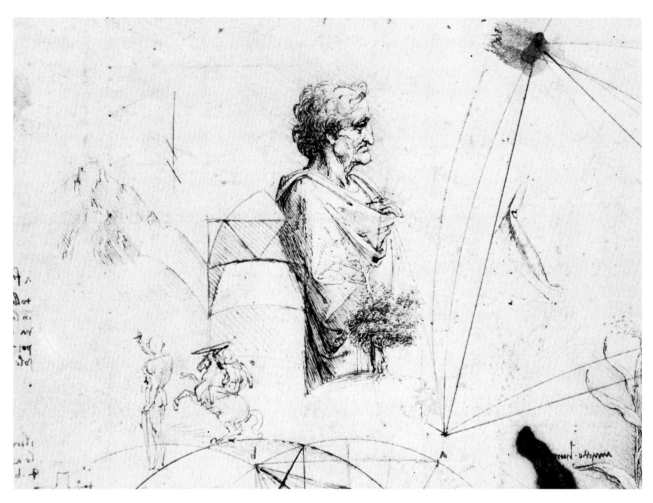

1A [Detail]

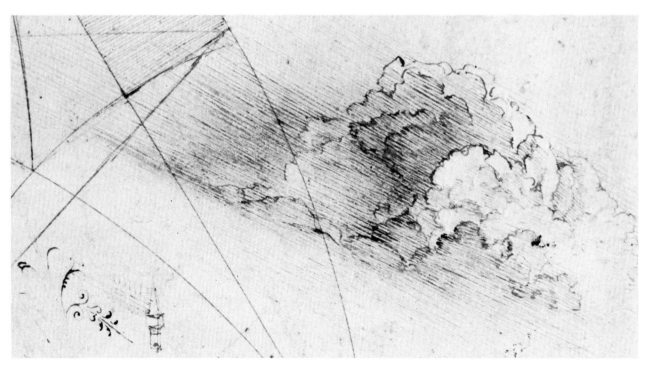

1A [Detail]

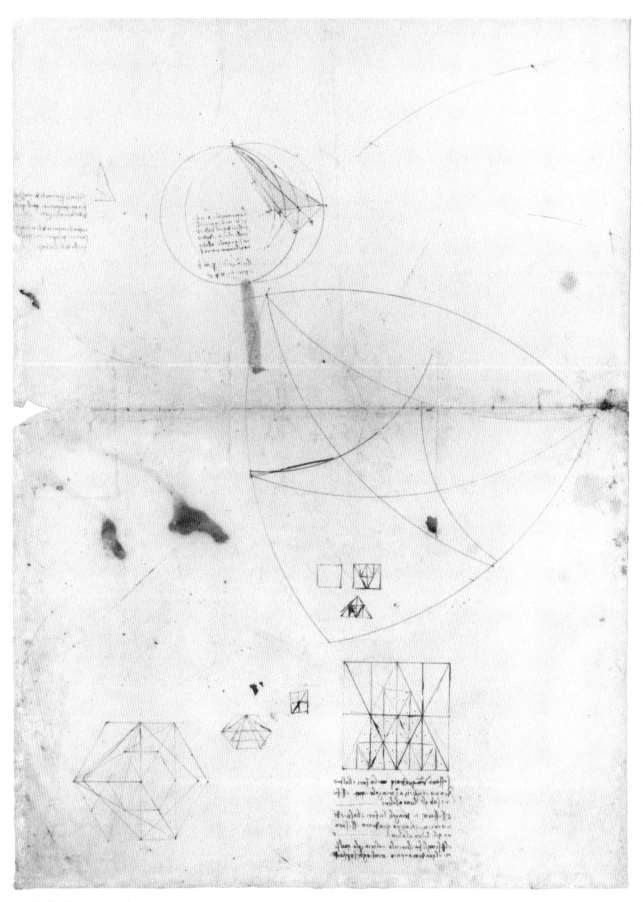

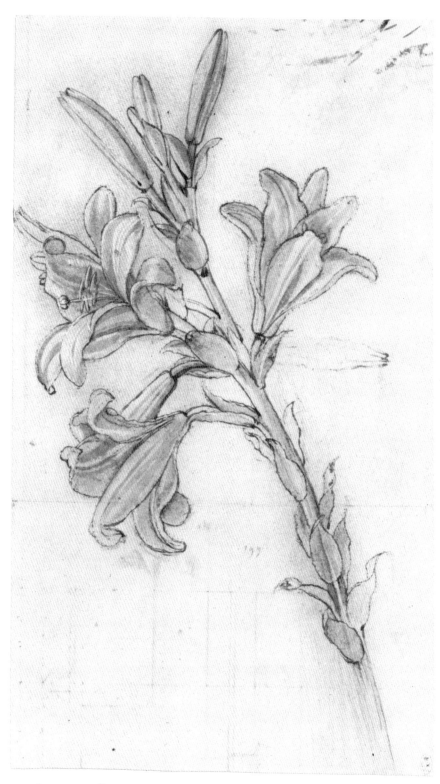

2 [RL 12418]

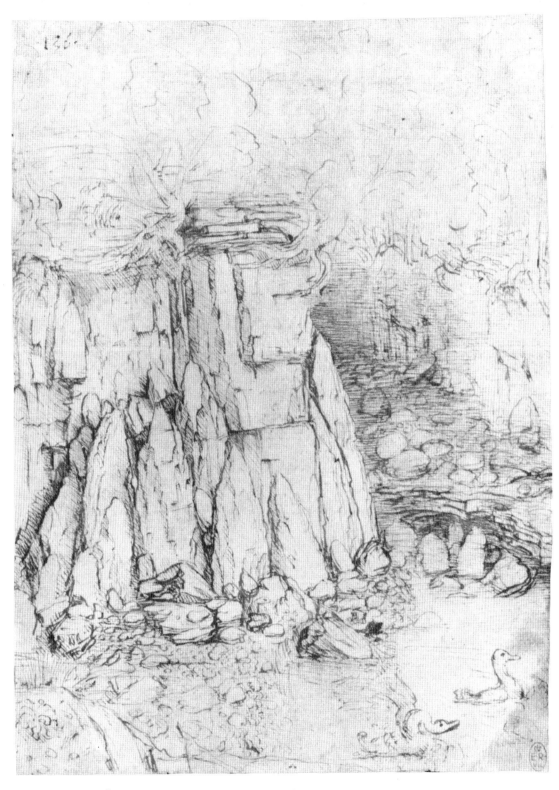

3 [RL 12395]

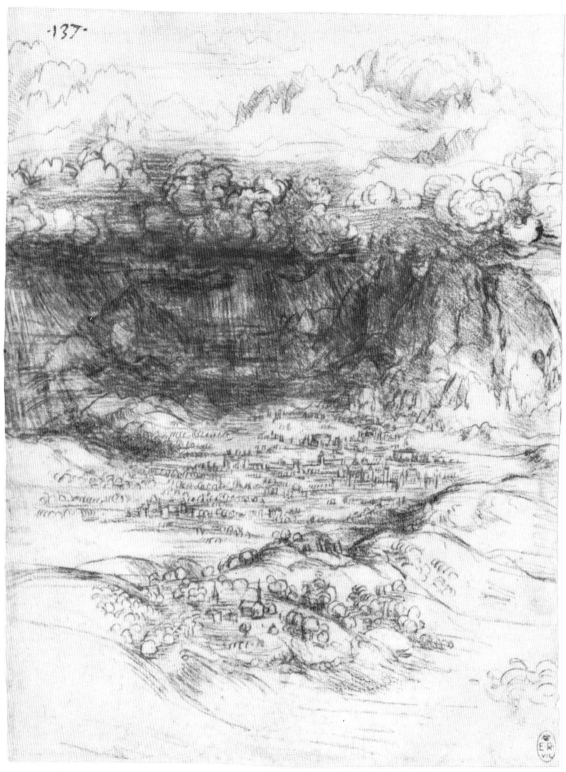

4 [RL 12409]

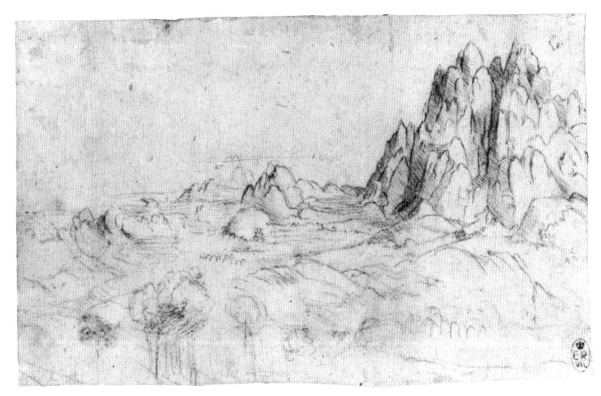

5 [RL 12405]

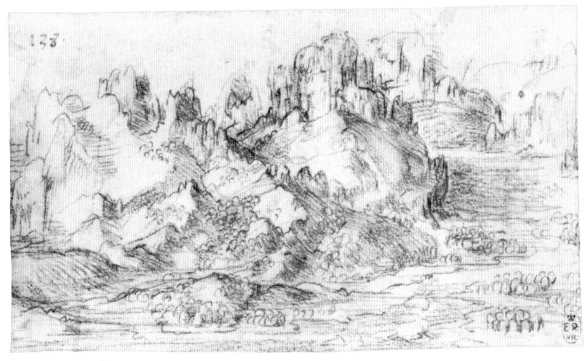

6 [RL 12406]

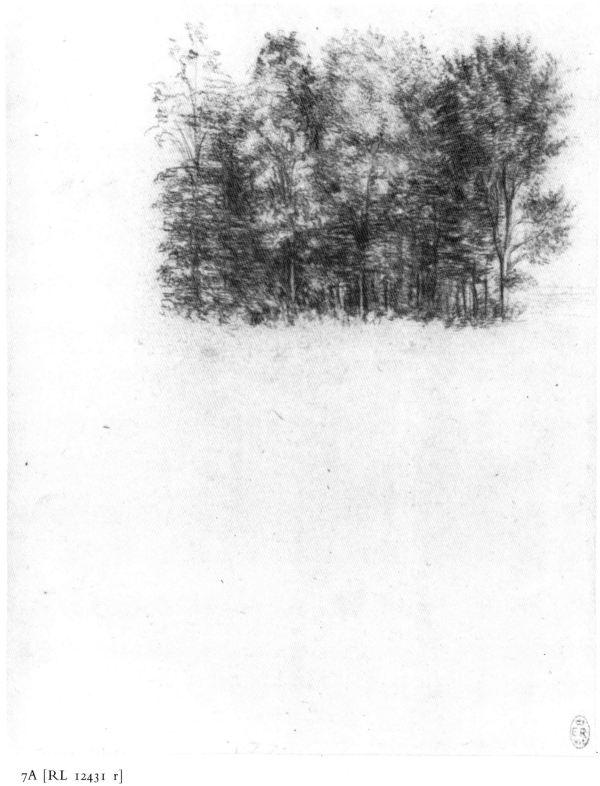

7A [RL 12431 r]

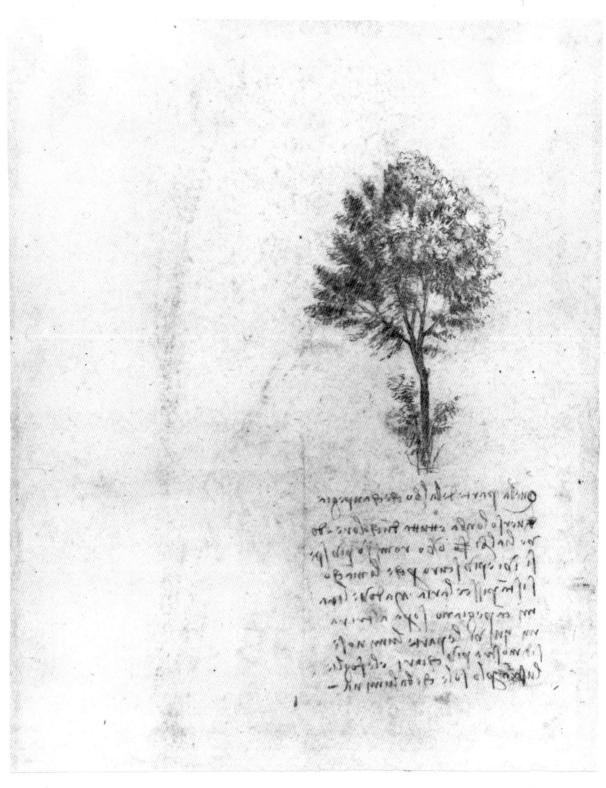

7B [RL 12431 v]

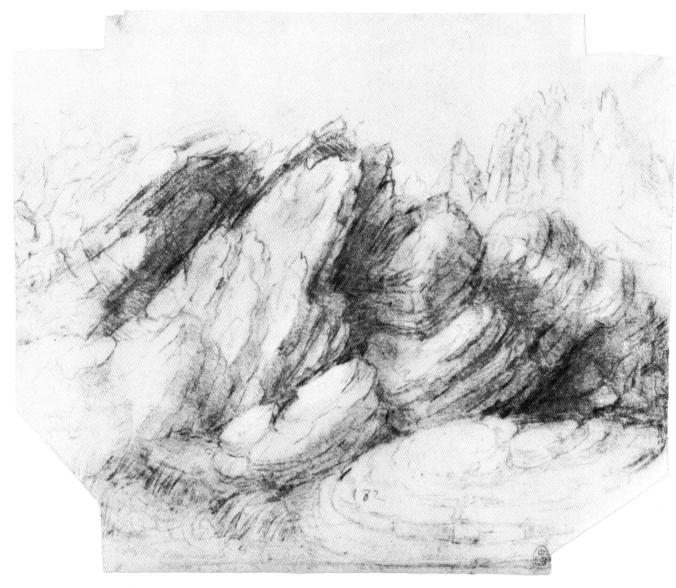

8 [RL 12397]

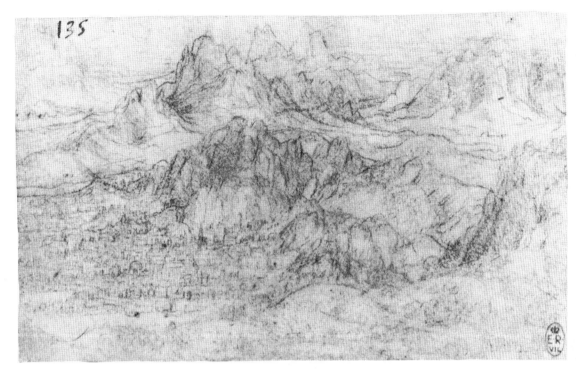

9 [RL 12407]

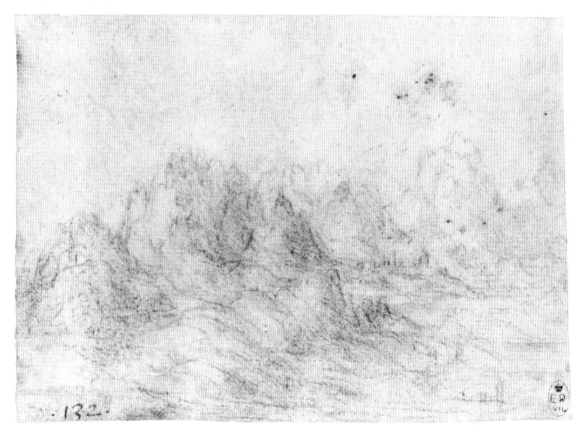

10 [RL 12408]

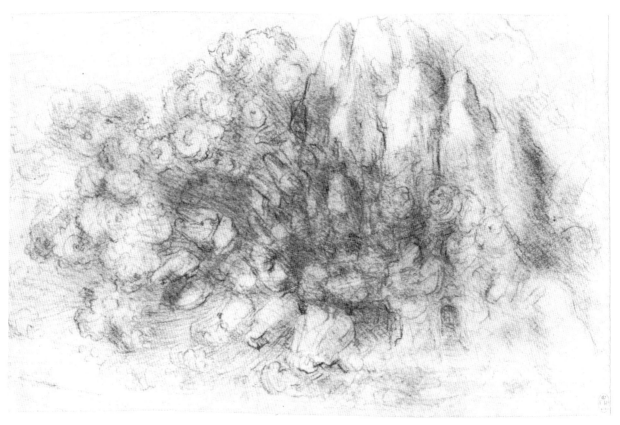

11 [RL 12387]

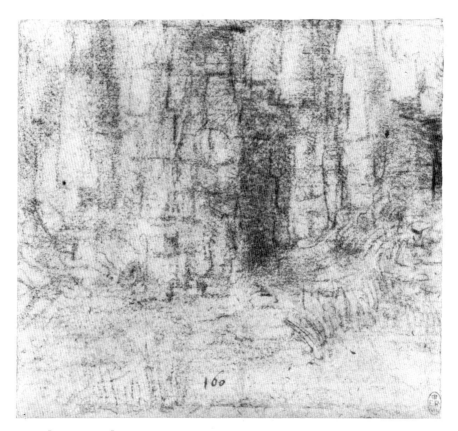

12 [RL 12390]

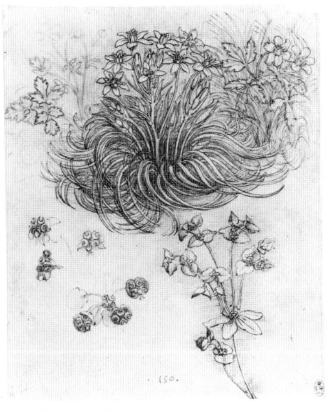

13 [RL 12424]

14A [RL 12430 r]

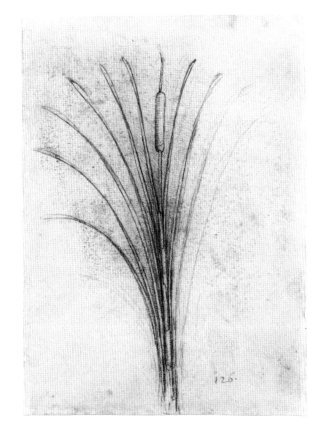

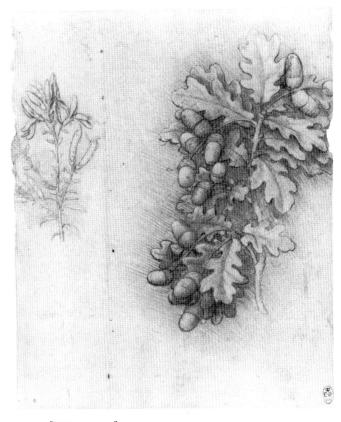

14B [RL 12430 v]

15 [RL 12422]

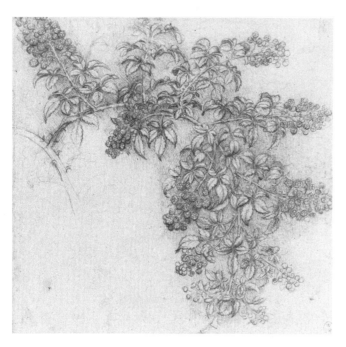

16 [RL 12419]

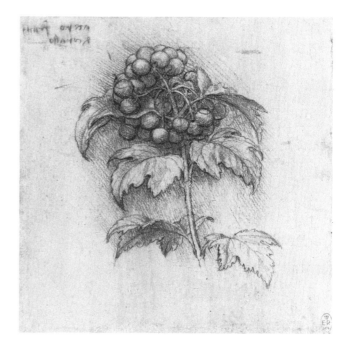

17 [RL 12421]

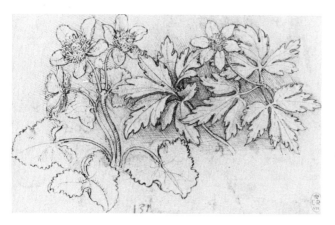

18 [RL 12423]

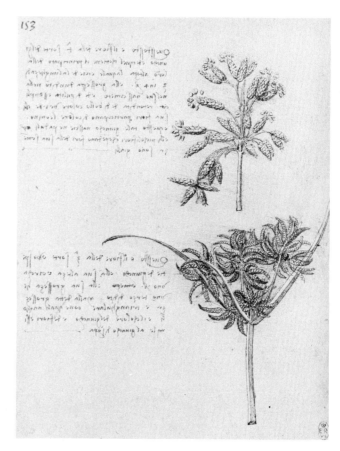

19 [RL 12427]

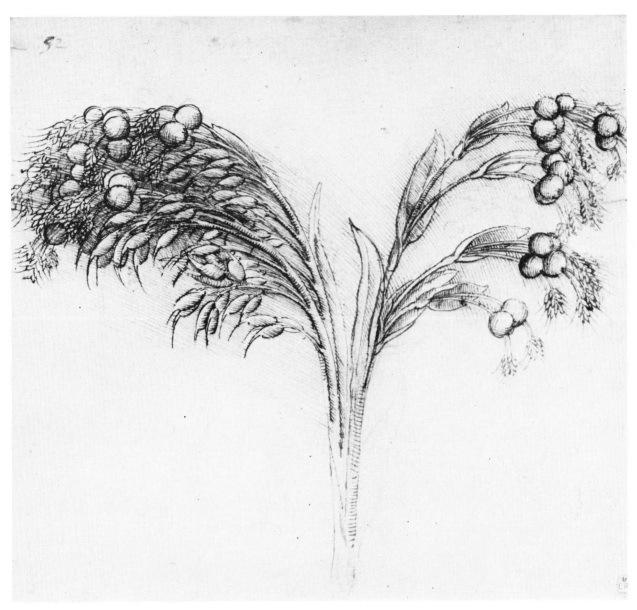

20 [RL 12429]

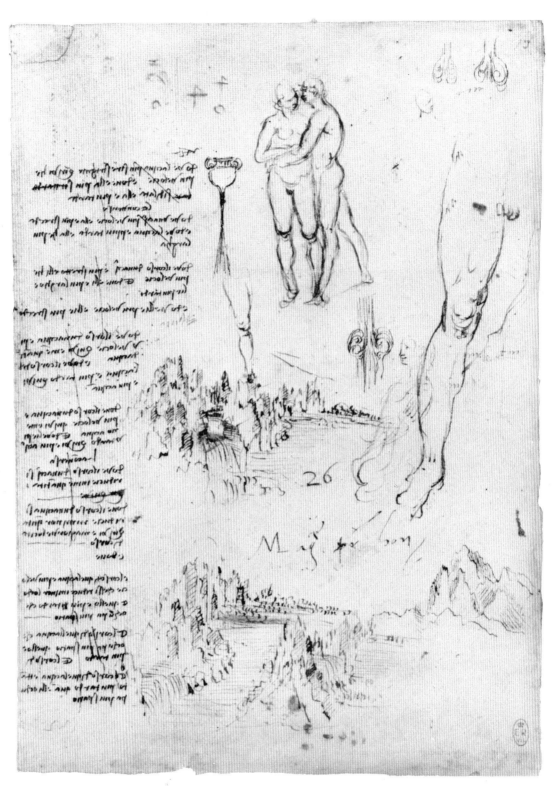

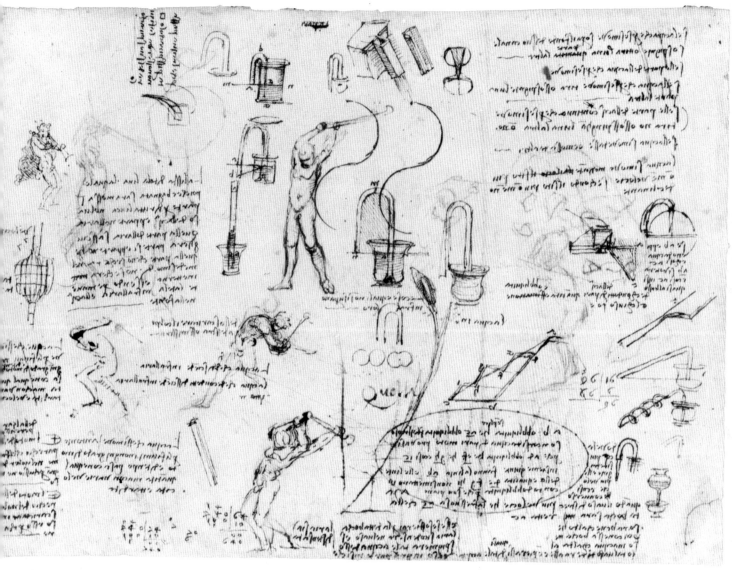

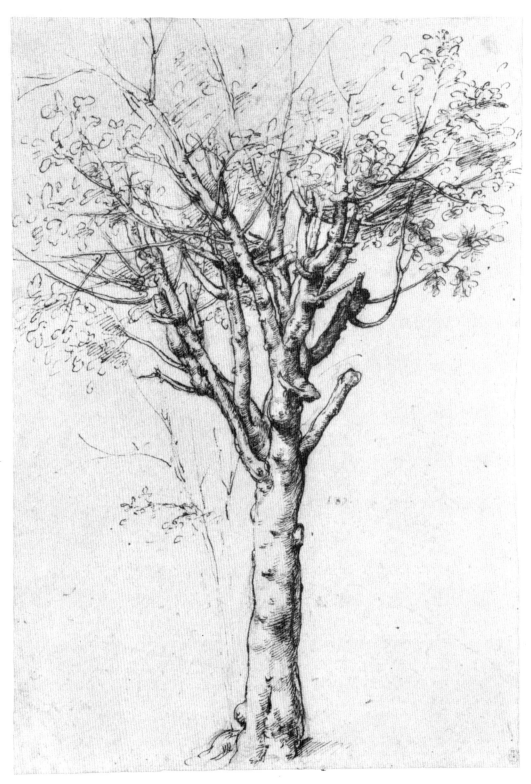

22 [RL 12417]

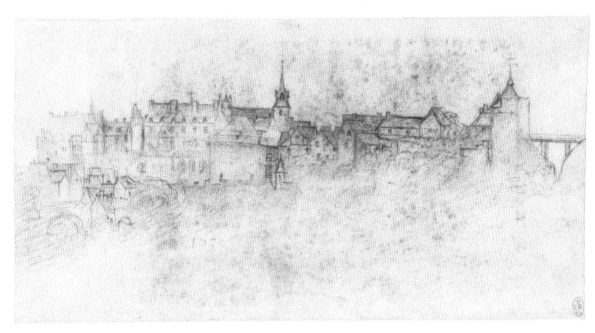

23 [RL 12727]

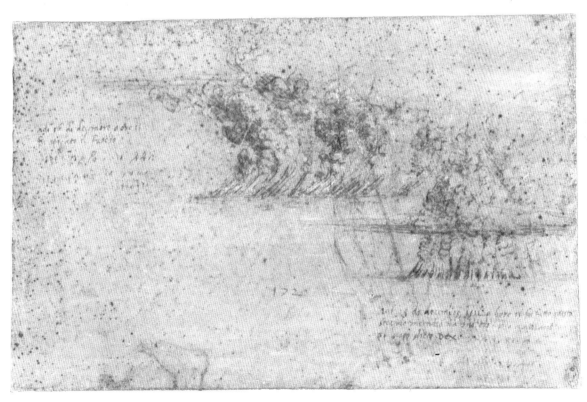

24 [RL 12416]

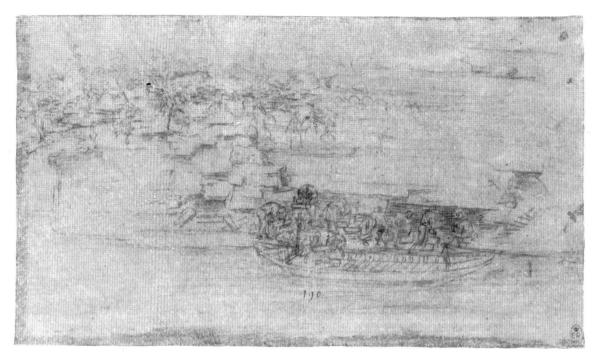

25 [RL 12415]

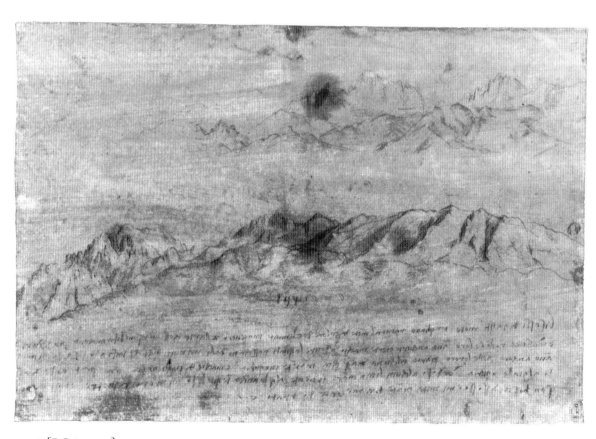

26 [RL 12414]

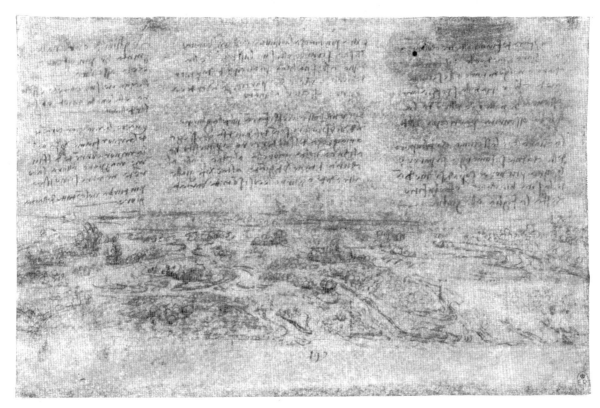

27 [RL 12412]

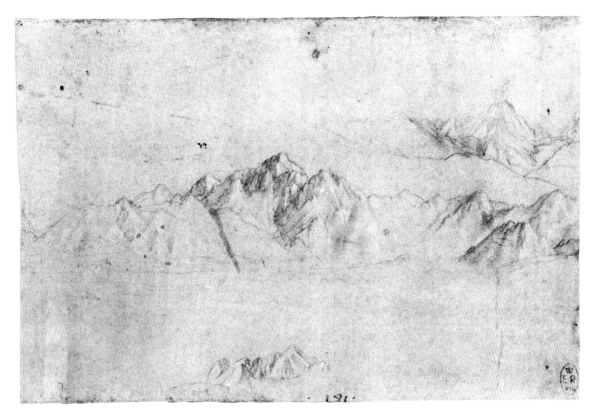

28 [RL 12410]

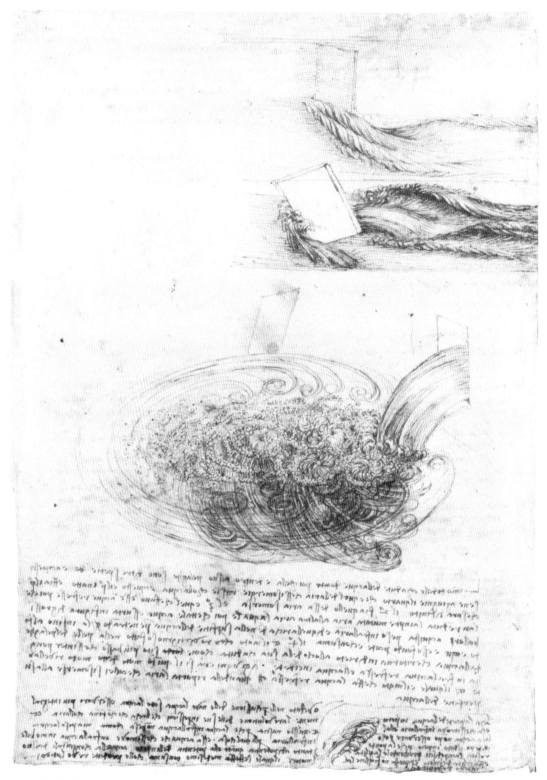

29A [RL 12660 v]

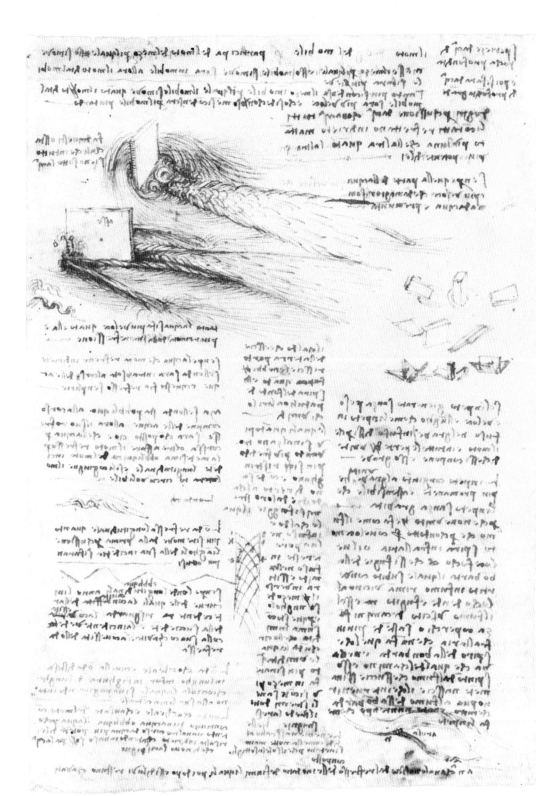

29B [RL 12660 r]

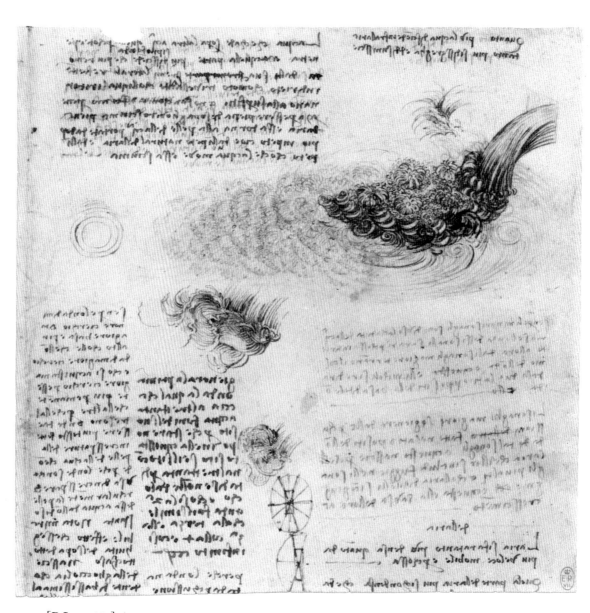

30 [RL 12661]

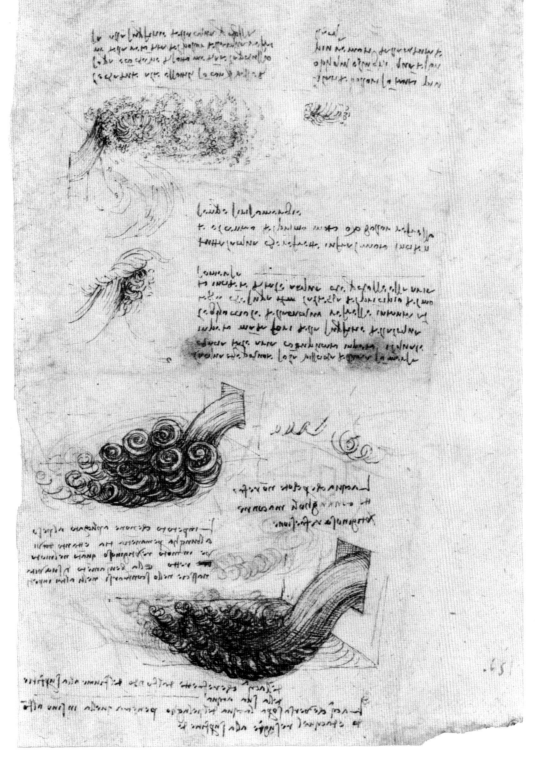

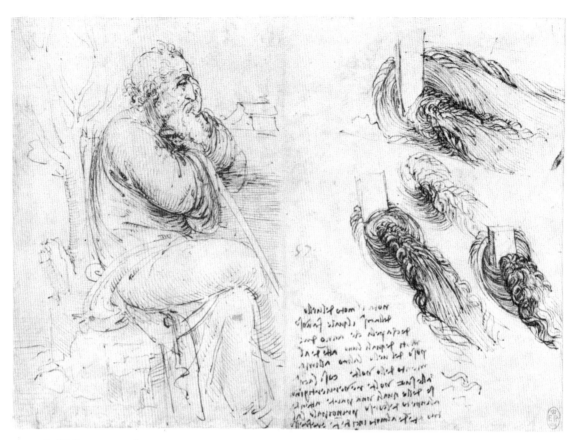

32A [RL 12579 r]

32B [RL 12579 v]

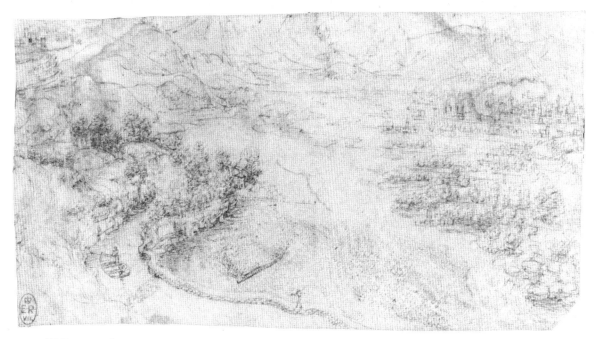

33 [RL 12398]

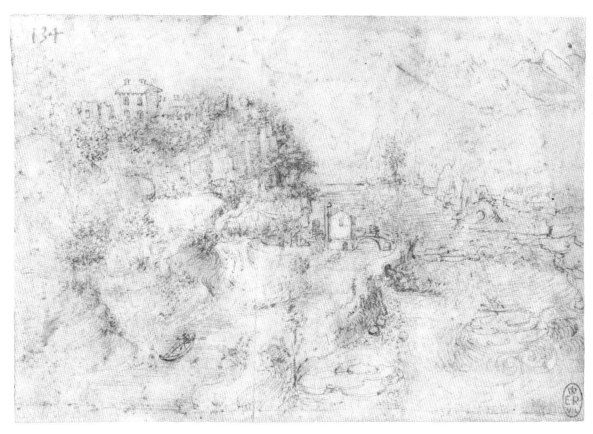

34 [RL 12399]

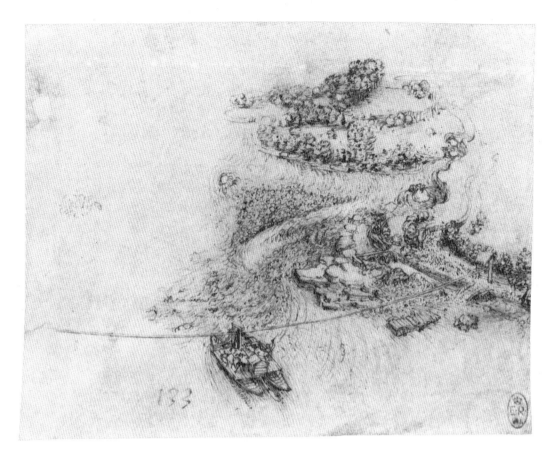

35 [RL 12400]

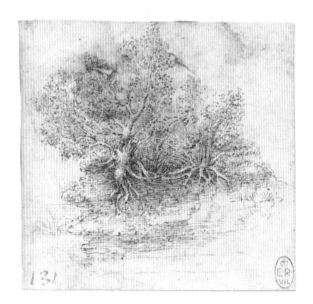

36 [RL 12402]

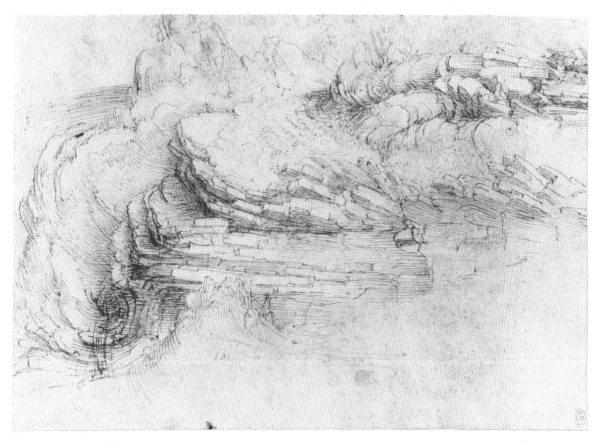

37 [RL 12394]

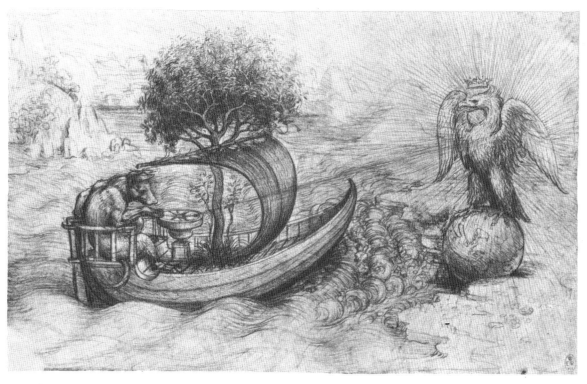

38 [RL 12496]

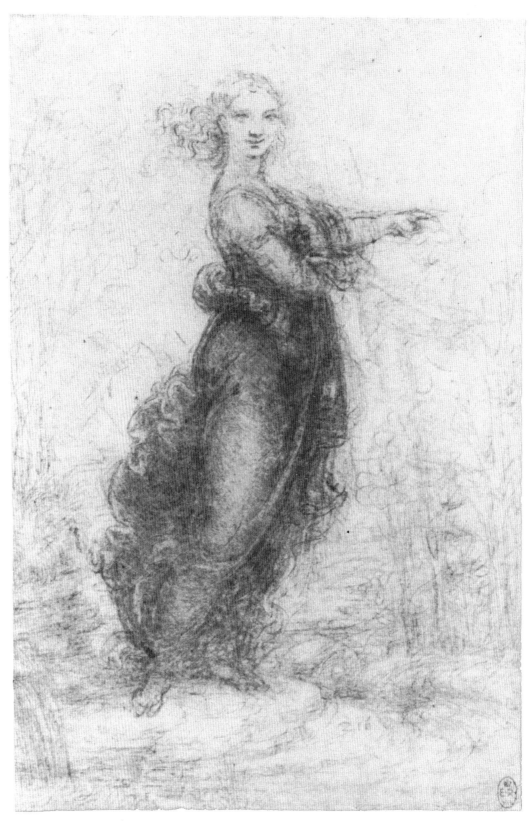

39 [RL 12581]

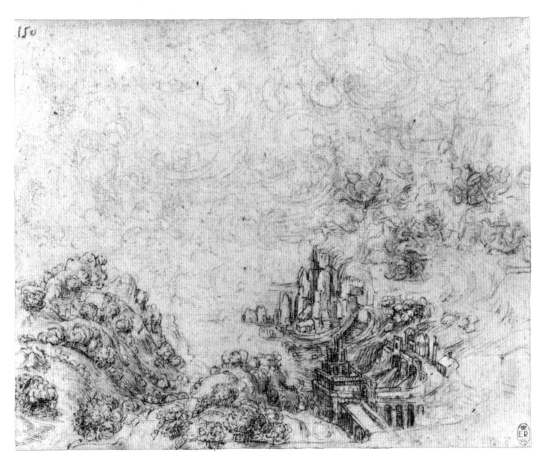

40 [RL 12401]

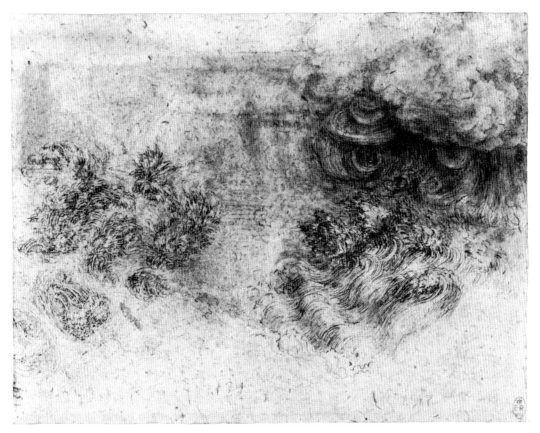

41 [RL 12379]

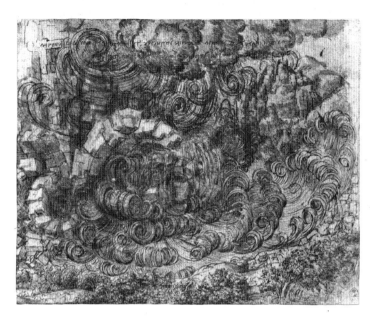

42 [RL 12380]

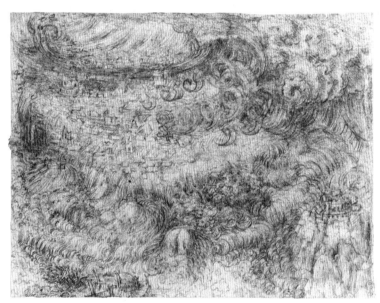

43 [RL 12385]

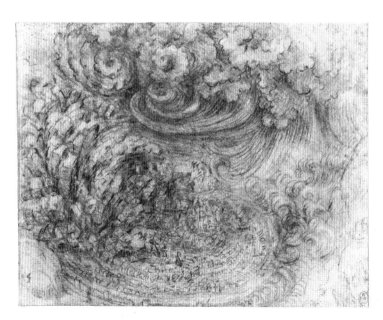

44 [RL 12378]

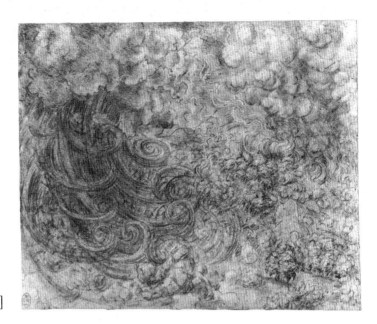

45 [RL 12384]

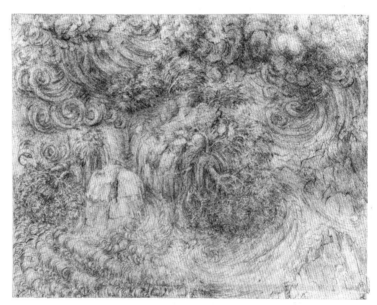

46 [RL 12386]

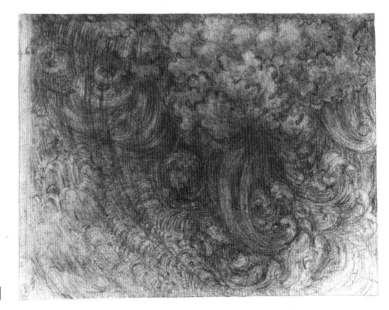

47 [RL 12383]

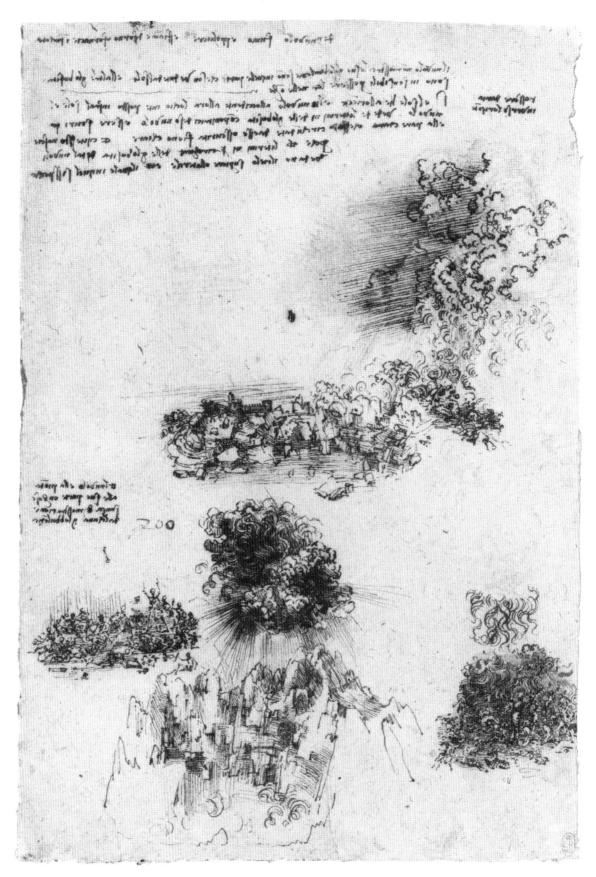

48 [RL 12388]

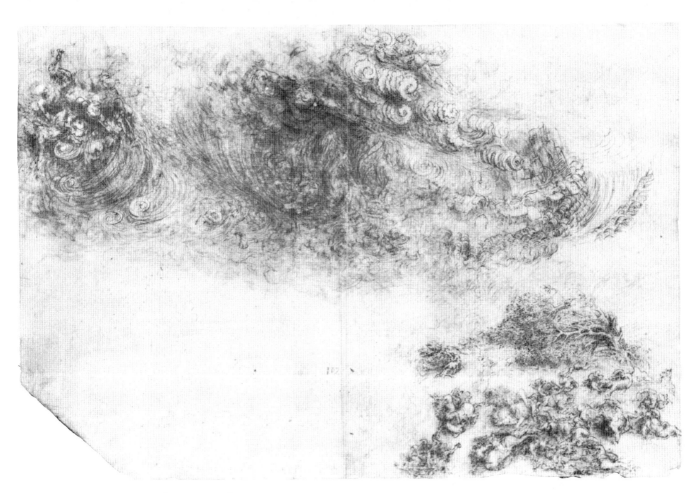

49 [RL 12376]

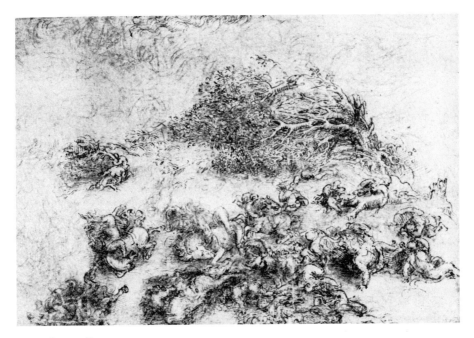

49 [Detail]

50A [RL 12665 v]

178

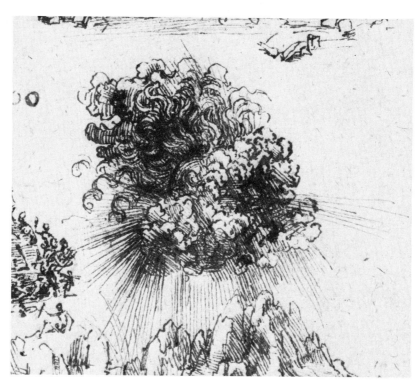

48 [Detail]

CHRONOLOGICAL TABLE

1452 Vinci	Birth of Leonardo
1470s Florence	Leonardo's first dated drawing, Arno Valley landscape, 1473 Leonardo working in Verrocchio's studio *Ginevra Benci*; Uffizi and Louvre *Annunciations* PLANT STUDIES: Lily (2)
1480s Florence Milan	*St Jerome*; unfinished *Adoration of the Magi*, 1481-2 Working in Milan, 1483-99 *Virgin of the Rocks*; Sforza Monument project LANDSCAPE STUDIES: Rocky ravine (3) Plant studies in Paris MS. B, *c.* 1487-90 'Theme sheet', *c.* 1489 (1)
1490s Milan	*Last Supper*, *c.* 1495-7; *Sala delle Asse*, *c.* 1498 Notes on landscape in Paris MS. A, *c.* 1490-2
1500s Venice Florence	Leonardo returned to Florence via Venice following French invasion of Milan in 1499 In Venice in 1500 1502-3, active as military architect for Cesare Borgia 1503-4, Arno canalisation project; Piombino LANDSCAPE STUDIES: Storm over a valley (4), Mountain peaks (5, 6) and copse of birches (7) *Battle of Anghiari* project, 1503-5; first *St Anne* cartoon, 1501; *Madonna of the Yarn Winder*, 1501; *Leda* and possibly *Mona Lisa* LANDSCAPE STUDIES: *Leda* plant series (13-20)
Milan	Returned to Milan 1506 and appointed '*Peintre et Ingénieur*' to Louis XII of France, 1507 *Burlington House cartoon*, 1506-8; second version of *Virgin of the Rocks*, 1508; Trivulzio Monument project, 1508-12; Louvre *St John*, 1509; studio activity (21-23) LANDSCAPE STUDIES: Mountain ranges (8-12) Water studies (29-32)
1510s Milan Florence Rome France	Travel between Milan, Florence and Rome in early part of decade, settling in Rome in 1513 Varese *St John in the Desert*, *c.* 1513; work on *Mona Lisa* and Louvre *St Anne*, after 1510 Medici Palace project, Florence 1515 Moved to France in 1517 and died there at Cloux, 1519, leaving all papers to Melzi LANDSCAPE STUDIES: Red series, 1511 (24-28) Adda River series, *c.* 1513 (33-37) Allegories and Deluge series, after 1515 (38-50)

91

TABLES OF CONCORDANCE

The concordance of catalogue numbers with Royal Library inventory numbers is as follows:

THE 'THEME SHEET'			RED SERIES	
1A & B	12283R & V		24	12416
			25	12415
EARLY STUDIES			26	12414
2	12418		27	12412
3	12395		28	12410

NARRATIVE LANDSCAPES

			WATER STUDIES	
4	12409		29A & B	12660V & R
5	12405		30	12661
6	12406		31	12662
7A & B	12431R & V		32A & B	12579R & V

BLACK CHALK MOUNTAIN SERIES

			ADDA RIVER SERIES	
8	12397		33	12398
9	12407		34	12399
10	12408		35	12400
11	12387		36	12402
12	12390		37	12394

LEDA PLANT SERIES

			SYMBOLIC LANDSCAPES AND DELUGE SERIES	
13	12424		38	12496
14A & B	12430R & V		39	12581
15	12422		40	12401
16	12419		41	12379
17	12421		42	12380
18	12423		43	12385
19	12427		44	12378
20	12429		45	12384
			46	12386
STUDIO SERIES			47	12383
21A & B	12641R & V		48	12388
22	12417		49	12376
23	12727		50A & B	12665V & R

The concordance of Royal Library inventory numbers with catalogue numbers is as follows:

Royal Library	Exhibition		Royal Library	Exhibition
12283R & V	1A & B		12383	47
12376	49		12384	45
12378	44		12385	43
12379	41		12386	46
12380	42		12387	11

Royal Library	Exhibition	Royal Library	Exhibition
12388	48	12417	22
12390	12	12418	2
12394	37	12419	16
12395	3	12421	17
12397	8	12422	15
12398	33	12423	18
12399	34	12424	13
12400	35	12427	19
12401	40	12429	20
12402	36	12430R & V	14A & B
12405	5	12431R & V	7A & B
12406	6	12496	38
12407	9	12579R & V	32A & B
12408	10	12581	39
12409	4	12641R & V	21A & B
12410	28	12660R & V	29B & A
12412	27	12661	30
12414	26	12662	31
12415	25	12665R & V	50B & A
12416	24	12727	23

Concordance with Pedretti Edition:

P	Exhibition	P	Exhibition
1R & V	1A & B	38R	26
2R	2	39R	27
3R	3	40R	28
5R	4	42R & V	29A & B
6R	5	44R	30
7R	6	47R	31
8R & V	7A & B	48R & V	32A & B
9R	8	49R	33
12R	9	50R	34
13R	10	51R	35
14R	11	52R	36
15R	12	53R	37
16R	13	54R	38
17R & V	14A & B	55R	39
18R	15	56R	40
19R	16	57R	41
21R	17	59R	42
23R	18	60R	43
24R	19	62R	44
25R	20	64R	45
32R & V	21B & A	65R	46
34R	22	66R	47
35R	23	67R & V	50A & B
36R	24	68R	49
37R	25	70R	48

LIST OF ABBREVIATIONS

CA — *Il Codice Atlantico di Leonardo da Vinci nella Biblioteca Ambrosiana di Milano*, ed. Giovanni Piumati, Milan, 1894-1904

Calvi — G. Calvi, *I manoscritti di Leonardo da Vinci dal punto di vista cronologico, storico e biografico*, Bologna, 1925

K/P — K. D. Keele and C. Pedretti, *Leonardo da Vinci: Corpus of the Anatomical Studies... at Windsor Castle*, London and New York, 1979-80

Lu — *Leonardo da Vinci. Das Buch von der Malerei...*, ed. H. Ludwig, Vienna, 1882

MacCurdy — *The Notebooks of Leonardo da Vinci*, ed. E. MacCurdy, London, 1938

McM — *Leonardo da Vinci, Treatise on Painting*, ed. A. P. McMahon, Princeton, 1956

P — *The Drawings and Miscellaneous Papers of Leonardo da Vinci... at Windsor Castle*, ed. C. Pedretti, London and New York, 1981

Richter — *The Literary Works of Leonardo da Vinci*, ed. J. P. Richter, 2nd edn., Oxford, 1939

Richter *Commentary* — C. Pedretti, *The Literary Works of Leonardo da Vinci edited by J. P. Richter. Commentary*, Oxford, 1977

RL — Inventory of the Royal Library, Windsor Castle. See *Windsor Catalogue*.

Windsor Catalogue — *A Catalogue of the Drawings of Leonardo da Vinci... at Windsor Castle*, Cambridge, 1935, 2 vols. Second edition, revised with the assistance of Carlo Pedretti, London, 1968-69.

BIBLIOGRAPHICAL NOTE

The numerical references to drawings at Windsor in the text are to Royal Library inventory numbers (RL). They correspond to the numbers of the catalogue entries in Kenneth Clark's catalogue of the whole collection of Leonardo's drawings at Windsor (*Windsor Catalogue*), first published in 1935 and in a second edition (revised with the assistance of Carlo Pedretti) in 1968-69. The landscape drawings, plant and water studies are now gathered in a corpus of facsimiles edited by Carlo Pedretti (London-New York, 1981). As Volume I of the planned publication of all Leonardo drawings and miscellaneous papers at Windsor, this follows the edition of the *Corpus of Anatomical Studies* just published in three volumes (Kenneth D. Keele and Carlo Pedretti editors), London-New York, 1979-80.

Leonardo's nature studies are discussed in almost every book on Leonardo. The best introduction to the subject is provided by A. E. Popham's edition of Leonardo's Drawings (London, 1945). See also *Leonardo da Vinci. Landscape and Plants*, edited by Ludwig Goldscheider, London, 1952. Leonardo's writings on landscape and related topics are conveniently gathered in the anthologies by Richter (1883; second edition, 1939) and MacCurdy (1938), as well as in the *Treatise on Painting* (McMahon's edition, Princeton, 1956). See also my *Commentary* to the Richter anthology (Oxford, 1977).

The bibliographies included in these publications can be supplemented as follows:

Castelfranco, Giorgio, *Studi Vinciani*, Rome, 1966 (pp. 125-42: *Il paesaggio di Leonardo*).

Emboden, William A., 'A Renaissance Botanist: Leonardo da Vinci', *Hortulus aliquando*, I, 1975-76, pp. 13-29.

Gombrich, Ernst H., 'Renaissance Theory and the Development of Landscape Painting', *Gazette des Beaux-Arts*, XLI, 1953, pp. 335-60.

Gould, Cecil, *Leonardo. The Artist and the Non-Artist*, London-Boston, 1975.

Heydenreich, Ludwig H., 'Qui è la veduta: Über einige Landschaftzeichnungen Leonardo da Vincis im Madrider Skizzenbuch (Cod. 8936)', in *Studies in Late Medieval and Renaissance Painting in Honor of Millard Meiss*, New York, 1977, vol. I, pp. 241-48.

Hoffman, V., 'Leonardo Ausmalung der Sala delle Asse im Castello Sforzesco', *Mitteilungen des Kunsthistorischen Institutes in Florenz*, 1972, I, pp. 51 ff.

Leonardo's Legacy. An International Symposium, edited by C. D. O'Malley, Berkeley-Los Angeles, 1969 (in particular the papers by J. S. Ackerman and E. H. Gombrich).

Morley, Brian, 'The Plant Illustrations of Leonardo da Vinci', *Burlington Magazine*, CXXXI, 1979, pp. 553-60.

Pedretti, Carlo, *Leonardo. A Study in Chronology and Style*, London, 1973 (chapter I: *The River*).

PRINTED IN FLORENCE, ITALY
BY GIUNTI BARBÈRA